Centerfolds
by Charlotte Kemp

ISBN 978-1-63393-160-2

Published by

 köehlerbooks™

210 60th Street,
Virginia Beach, VA 23451
www.koehlerbooks.com

CENTERFOLDS

A COLLECTION OF STORIES BY

Charlotte Kemp

MISS DECEMBER 1982

VIRGINIA BEACH
CAPE CHARLES

Dedication

This book is dedicated to every Centerfold who has brought her true story to life. These women have opened up and let their guard down so that fans and readers will understand them and have a glimpse into their real lives.

TABLE OF CONTENTS

Charlotte Kemp – Miss December 1982 *10*

Pushed into "The Big Break" 15
Grottomania 16
My Gatefold Shoot 17
Japan Here I Come 18
Menage a Trois 19
Tom Staebler–Playboy Executive 20
Boston Promotion Debacle 21
Playmate Olympics 22
Playmate Video 23
Lee Wolfberg 24
Da' Bears . 25
Howard Cosell 26
Bestiality . 26
The Porno Star and his Girlfriend 27
Miss Budweiser 28
Enzo Ferrari and My Formula 1 Days 29

Judy Tyler – Miss January 1966 *32*

Casting Couch Creep 34

Dede Lind – Miss August 1967 *36*

My First Modeling Jobs 38
Becoming a Playmate 38
To the Moon 38
Celebrity Sleuths, Cynthia Myers
and Steve Sullivan 39

Reagan Wilson – Miss October 1967 *40*

 Entertaining the Troops 42

 Playmates on the Moon 43

 They Shoot Bunnies, Don't They? 44

 The Hong Kong Shipping Magnate 45

Nancy Harwood – Miss February 1968 *46*

 As Seen on TV 48

Cynthia Myers – Miss December 1968 *52*

 Riots and Celebrities 54

 The Lesbian Scene 55

 Portraits of Vietnam 57

 Hugh Hefner and Bill Cosby 58

 Jay Sebring and Charles Manson 59

Vicki Peters – Miss April 1972 *62*

 How I Became a Playmate 64

 Elvis and Me . 64

Bonnie Large – Miss March 1973 *68*

 The Mile High Club 72

 I Coulda Been a Contessa 73

 Gene Simmons and Michael Crichton 74

 Farewell My Lovely, Jerry Bruckheimer . . . 86

Carol Vitale – Miss July 1974 *78*

 Being Discovered 80

 Not Always So Glamorous 81

Janet Lupo – Miss November 1975 *82*

 How I Became a Playmate 84
 Billy Jack and Disneyland 84
 Centerfold Flight Attendant 85

Pamela Bryant – Miss April 1978 *88*

 My Poem 90
 Arriving at the Mansion 91
 OJ Simpson 93
 Warren Beatty 94

Liz Glazowski – Miss April 1980 *96*

 Becoming a Playmate 98
 Oops . 98
 Ken Marcus 99

Kym Malin – Miss May 1982 *102*

 How it Started 104
 The Playboy Mansion 105
 Tom Cruise 107
 Robin Williams 107
 John Belushi 109
 Mansion and Hef 109
 Ray Manzella 110

Marlene Janssen – Miss November 1982 . . *112*

 The Fantasy 114
 The Beginning of the Fantasy 114
 My Tests and Journey into
 Centerfold History 115
 Hef Liked Me Just As I Was 116
 Promotions – Michelob Light
 and Racing 117
 "Kiss" in the Big Easy 118
 In Love and Out with Gene 119

Alana Soares – Miss March 1983 *122*
 The Bold Peeping Tom 124
 The Purple One–Prince 126

Patty Duffek – Miss May 1984 *130*
 How I Was Discovered 132
 Psycho-Cop 133

Devin DeVasquez – Miss October 1985 . . . *136*
 Discovering the Pinup in Me 138
 How I Met My Husband 143

Kat Hushaw – Miss October 1986 *146*
 Guests of the Island King–Tom Selleck . . 148

Carmen Berg – Miss July 1987 *150*
 Getting Started 152

Cindy Guyer –
Celebrity Pictoral March 1999 *156*
 Playboy and the First Shoot 158
 Changing the Theme 159
 Family Values 159

Arny Freytag –
Celebrated Centerfold Photographer *162*
 Bora Bora . 164
 Mexico . 164
 Acapulco . 165
 Russia . 166
 Bad Attitudes 167

Ken Marcus –
Celebrated Centerfold Photographer 170

South Padre Island and Gig Gangel,
Miss January 1980 172
Luckenbach Sometimes
Annual World Fair 173
Drunken Playmate Experience 173
Dorothy Stratten Christmas Blaze 174
Last Sighting of Dorothy 175

Ric Moore –
Celebrated Centerfold Photographer 176

How I Became a Playboy Photographer . . 178
National Search 180

Mykyla Moore – Celebrated Centerfold
Photographer and model. 184

Cute British Accent and
Texas Size Boobs! 186
Part of the Playboy Crew. 187
Ric Moore and My J.R. Ewings. 188
My Big Break 188
Accolades, Life and Thank You 189

Ralph Haseltine – Celebrity Photographer
of Centerfolds. 190

How I Became a Photographer 192
How I Started Shooting Centerfolds 194
Malloy and Stephanie, Playboy Models,
Private Island Shoot 195
Jackie Morrison 198

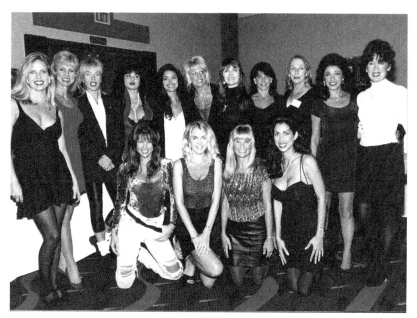

Photo by: Steve Kiefer

INTRODUCTION

I started collecting stories about twenty years ago from my sister "Centerfolds." I have always thought our Centerfold stories – not the manufactured ones from PR – are so much more interesting and real. The experiences of the Centerfolds reflect the era they lived in and the changes society went through. In the 1960s Centerfolds posed topless. By 1970s frontal nudity was in vogue in the U.S. and much of the rest of the world.

Centerfolds became as iconic as *Playboy* magazine. Both were part of the vernacular and culture. Soldiers took our pictures with them into battle; astronauts walked on the moon with pictures of us on their sleeves. The biggest names in Hollywood and Washington courted us, dated us and had sex with us – or at least tried. We travelled the world in private jets, or at least flew first-class.

Most of us were just out of high school and naive when swept into this world of the rich, powerful and famous. Being shy wasn't an option: we all had to learn very quickly how to cope and how to handle ourselves. Fortunately, most of us had a very strong support from other Centerfolds or staffers from the vast Playboy network. Hef used to call it the "Playboy family," and to some extent he was right – we were family, a wild, crazy family.

Most of us grew up very fast and learned to distinguish between the good guys and the not-so-good. Some of the big names we encountered were gentlemen and some were jerks, and it didn't take long to learn who was who. We were professional partiers, but we were also people with feelings, broken hearts and a desire to be good citizens.

For most men in America we were simply "Girls Next Door," the voluptuous, smiling beauties they fantasized being with. Our

stories, along with those of some of the famous photographers who photographed us, provide a behind-the-scenes look at our lives as Centerfolds. You'll see us in our primes, coming up through Playboy and into stardom. But you'll also see us as career women, mothers and citizens with a desire to make people smile and do some good.

I decided to assemble this collection of stories because, at its essence, it is a slice of Americana. Being a Centerfold is a membership in an exclusive sorority, partly because there are only twelve of us a year. Moralists or the prudish may condemn us, but no one can deny that our lives, and the paths we have travelled, have provided a rare view of life. We have stepped through doors and been in places few can imagine.

The stories included here were told to me, or written for me. Each story reflects first-hand accounts and personal experiences, as recalled by the storytellers. Each story is, to the best of the storyteller's recollection, factual and accurate. None are based on second-hand accounts or hearsay, and none are intended to do anything other than share these remarkable experiences of life in the fast-lane. Some are tragic and some are funny, but all come from the heart.

This book has been a labor of love and honesty from these Iconic Centerfolds, Photographers and Celebrity Models. Our stories range across the spectrum of our younger lives, Playboy, and beyond. Centerfolds are true Americana as we have grown with America for seven decades. These are true stories from our lives. So get ready for the real "girls next door."

Charlotte Kemp – Miss December 1982

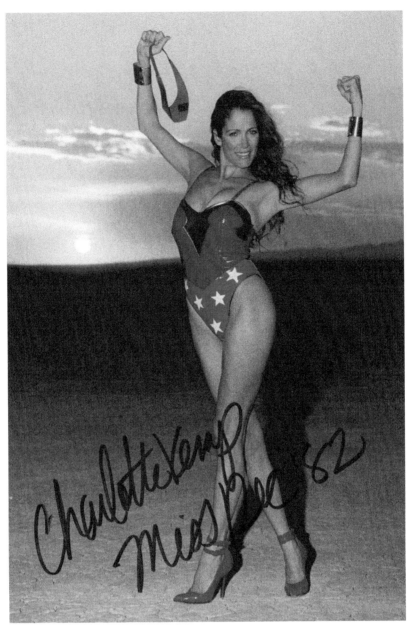

Photo by: John Perrige

Charlotte Kemp –
Miss December 1982

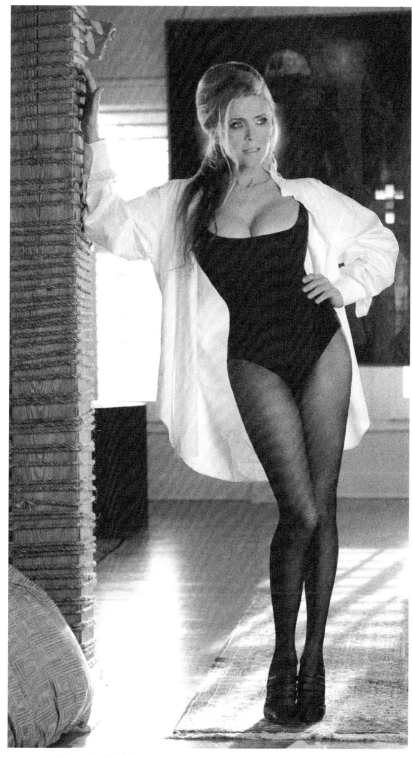

Photo by: Ric Moore photography, stylized by Mikki Moore, 2014

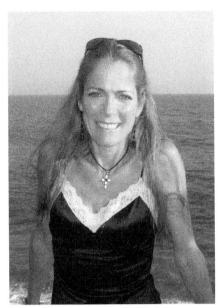

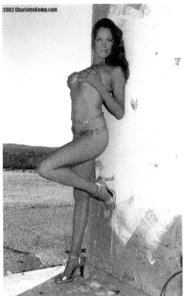

Photo by: John Perrige

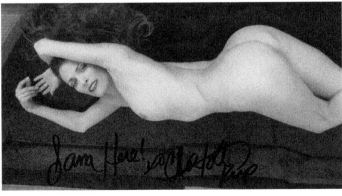

Photo by: Mikki Moore

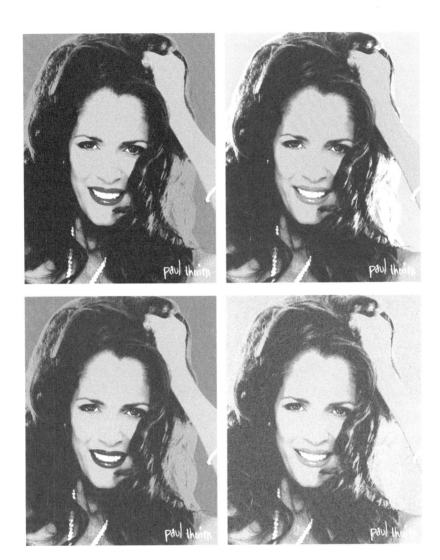

All photos used with permission by Charlotte Kemp

PUSHED INTO "THE BIG BREAK"

In the fall of 1981, I moved to Chicago to start my life as a model and world traveler. I was introduced to the Playboy Modeling Agency, and have always felt there was a great connection there, especially with the wonderful Vicki Chiconis, who was the Director of the legitimate modeling agency. She had always warned me not to be a Playmate because it would consume me. She had no idea.

She signed me up to be a contestant in the Miss Stolichnaya Contest. I thought, *Great!* I was big vodka drinker. It was there I met one of my best friends in Chicago, Jill DeVries, Playboy's Miss October 1976. She and I drank our way through the contest and I ended up first runner-up. How I ended up as first-runner up is still beyond me as I was drunk most of the time. I did, however, catch the eye of one of the contest judges, Gary Fencik, who played for the Chicago Bears. He became my boyfriend through some deceit on his part.

I was living next to the Playboy Mansion with a girl who was a model. She had also been in the contest and had a huge crush on Gary. He asked her on a date, pretending to to be interested in her, but it was a ruse to get to me. The three of us went out and he danced with me most of the night and made his intentions clear. My roommate threw me out, in anguish and unrequited love, lust or whatever, onto the street.

Jill and I had became fast friends and, after that episode, roommates. We partied together and she showed me Chicago. We were in *Risky Business* playing hookers, although I was edited, cut out because the smoke machine made me sick and I threw up all over the set.

She and I had so much fun all over Chicago. She was nine years older and she really opened my eyes to the world. We had a great apartment above Morton's on State Street. We didn't have a lot of furniture, but we had enough to have lots of fun. When we were shooting *Risky Business*, she was sleeping with the star of the movie. They made a lot of noise and, I assume, had a great time. I started dating Gary and was slowly accepted into the Chicago Bears inner circle. He actually was my perfect

date on my data sheet!

Jill had suggested more than once that I should test for Playboy. I had never taken my clothes off for any photos and was reluctant to do so. One summer evening in 1982 we sat and had some wine. I remember it was a Saturday night and we had just started partying. She said, "C'mon, Char, just test to see if they want you!" I was high enough and agreed. We schlepped down to the Playboy Studio where she introduced me to photographer David Mecey who told me being a Playmate could be lucrative. It was his first test shoot, and how sweet he was.

At first there was no way I was going to take my clothes off and be photographed for a magazine. You have to understand I had a 34-DDD chest and was very, very self-conscious. I had been an athlete: tennis, swimming, running. My chest had only been bestowed upon me during the last two years (I was a late bloomer, literally). I came from a very conservative Midwestern family. But, Jill and I came to an agreement – I would test shoot for Playmate.

We had already drunk a bottle of wine before leaving for the shoot and then we drank some during the shoot. I could not tell who was in front of me or what clothes I did or did not have on. The photos were sent in that evening to Playboy, and that night I was accepted. Sunday morning, Playboy sent a limo to pick me up to go to LA. I was absolutely freakin' out. First Class and me! Yowza! I felt I was in for a ride.

GROTTOMANIA

My very first experience at the Playboy Mansion was pure eroticism. I walked through the door of the mansion feeling and looking like a neophyte. It was all too much for a girl from the Midwest, still in college, modeling in Chicago and who seemed to be taking off in her life. I stood in the Mansion foyer and looked around, stupefied. It took a few moments for the butler to come and show me to my room and, basically, give me the lowdown on the Playboy Mansion. Within twenty minutes I was by myself with nothing to do. Talk about feeling a like a tiny cog in a "Brazil" type of wheel. So I decided to cruise around the

mansion checking out the pool, tennis courts, game room – and then I found the Grotto.

Now sometimes from the outside, the Playboy Mansion looks fairly sedate, but you have to look inside the nooks and crannies to ogle at the reality of it all. I walked into the underground Grotto, which you can only get to by swimming in the pool under the waterfall, or you can walk into from a hidden side entrance. It was about two-thirty on a blazing hot afternoon in LA and there, in the Grotto, were eight people spread out on the different beds all in varying sexual positions, performing oral, anal or straight sex. One group had two girls doing each other and the guy looking quite neglected. The two other groups were in a 69 position or having straight sex. My eyes must have looked like saucers as I stood there watching.

I remember all of this in vivid detail. I had never seen, or even heard, of anything like this before. I was dumbfounded and sat there in the Grotto, watching in a state of shock. I was asked to join in, but I was having too much fun watching, and I was too shy and sexually inexperienced for something that wild and crazy. But I did learn something that day about myself; I enjoyed being a voyeur.

I found a friend that night, Lance Rentzel; he took an affinity to me that I never understood. He told me what to watch out for; he was my protector at the Mansion for a long time. He never touched me, but had a protective feeling for me. I thank you, Lance. Yes, down the road I heard about his tragic downfall: He had been convicted of exposing himself while he was still a L.A. Rams football player, but he never displayed anything like that to me, and he surely was my protector.

MY GATEFOLD SHOOT

Monday morning I was awakened to get ready to go to my *gatefold shoot*, which is the same as a Centerfold, for those outside of Playboy. I was taken to Ken Marcus' studio, and I was petrified. Ken was a very quiet, unassuming man, very soft-spoken – unless yelling at his assistants. They had a stage set up for me. I got into makeup and the whole job began. This way and

that, we ended up with me in a standing position, long legs, and a corset. Then they put my hair up in a ponytail, Pat Benatar-style. Then came the trimming of the bush: I stood there ready to shoot and I heard someone say, "Do something with her bush!" I was mortified and thought *What the fuck?* The makeup artist came over with scissors and told me to stand very still; she was going to trim my bush. I was totally freaking out and this chick was trimming my bush. I had to stand down after that and I asked Ken if I could have some wine or something that would relax me. I drank wine and he smoked. That was always the way we shot – wine and pot. We had fun later.

He took three shots with his Hasselblad, sent them to Playboy and I think it was the third shot that was accepted, and I was Miss December 1982. I was at the Playboy Mansion for two days after that, and then back to Chi-town. Yowza!

TO JAPAN
BY JASON MARSHON – IN HIS WORDS

Jason "Leg Center," was my stage name. In the late ‚70's and early 80's I was producing a show called *Miss Legs America*. By the third, fourth and fifth year I was doing it all with widespread press, and it went international. It had gotten the attention of a Canadian producer doing shows in Japan.

They wanted me to bring in the girl with the best legs in America, literally, Miss Legs International. Then they asked me if I could put on other pageants of women with good attributes. It seems sleazy and politically incorrect nowadays, but back then it was sort of a fun contest and things were a little wilder in the 70's and early 80's.

They asked me if I could bring somebody with the best *tush* and the best breasts. I recruited various people who had won contests and promotions, such as Miss Legs International, Miss Tush USA; then I met Charlotte Kemp, who I gave the title of *Miss American Breasts*. I thought they would like her in Tokyo, she had the best breasts in the world. They flew me and my girls into Tokyo saying you have the best job in the world. Once we got

there it was more like *Guinness Book of World Records.* They had the tallest man, the woman with the longest fingernails, people who had the No. 1 of everything.

We stayed at the Capital Hotel, we had escorts and they treated us like we were royals. When we did this TV show, I wasn't aware of it at the time but there was a lot of nudity on Japanese TV. They were very anxious to have all the girls go up on stage. Charlotte was told she would have to take her top off and show her best breasts in the world, and they kept trying to make her bikini tighter and tighter, which made her feel uncomfortable because basically there were twenty thousand people in the audience. Charlotte was having a panic attack before going on, and she asked for a Valium. They wanted to know more and more about her breasts and wanted her to move them here and there, showing all angles. The Japanese people were cheering and taking all these pictures.

We were told we couldn't go out of the hotel without an escort, which was part of their custom. Charlotte and I went out around eleven and snuck out to the bars in the Roppongi district: we had such fun and partied all night. There were nightclubs on every floor in a high-rise building and on every floor there were different types of music: disco, live music; it was great.

We were there for a week and wanted to go to China; Charlotte got a visa and went to Beijing, saw the Great Wall and stayed with a guy she met.

MÉNAGE A TROIS

I had always heard that if you saw people wearing white robes around the mansion it meant they had been involved in a sexual encounter in Hef's bedroom or some other place in the Mansion at Hef's request. It was my third time staying at the Mansion and, instead of staying at the guest house as usual, I was given a bedroom in the main house one door away from Hef's bedroom. I was delighted and extremely curious as to why I had lucked out. I soon found out.

I had been partying downstairs throughout most of the evening and was a bit tipsy when I went upstairs to sleep. I

had just gotten to sleep when I heard a knocking on my door. I replied, "It's open!" and to my surprise there stood Hef and Dr. Mark Saginor, Hef's private physician, both smiling with white robes on. I remember sitting up and asking them to come in. They came in and after a little foreplay we started what was to be my first *ménage a trois*.

Everything was fun until the door opened and a very surprised and very angry Shannon Tweed looked in on us. She scowled and slammed the door shut. I remember feeling a little weird and caught in the middle because Shannon Tweed was Hef's girlfriend at the time. But this was the Mansion and this was Hef! The *ménage a trois* ended, and Hef assured me that everything would be okay.

The next day Shannon Tweed was in a nasty mood that seemed to be directed at me. I started to feel bad when she made a couple of remarks to me. Even her entourage were taking potshots at me. It was awful, so I went to talk to Hef.

Not long after I talked to Hef, Shannon realized that I didn't initiate the *ménage a trois* and apologized. White robes after that were not so taboo, but kind of "tongue-in cheek" for me.

TOM STAEBLER – PLAYBOY EXECUTIVE

Just before I became a Playmate, I worked for Playboy Models as a regular model – with my clothes on. I met a lot of Playboy executives in Chicago, including handsome, sophisticated Tom Staebler. I thought he was adorable, and he certainly loved me. He asked me out a few times and I remember we had dinner and went to Tom's beautiful corner apartment on State Street overlooking Lincoln Park. This apartment was truly spectacular, especially to a nineteen-year-old from Toledo, Ohio. But at this time, I was seeing Gary Fencik who played for the Chicago Bears and I was not into multiple partners. However, I was very attracted to Tom, who wanted me to stay over. I was very reluctant, but after consuming quite a few glasses of champagne, I more or less passed out. Tom was a perfect gentlemen and I

woke up and toddled home.

One of our last times together, though, I think I had frustrated him enough as I still would not sleep with him. So we compromised. He would masturbate and I would watch. I laugh at this today, thinking what a really great guy he was and how I was hung up on Gary Fencik. Tom picks the photos and the girls who do the cover of Playboy magazine and one year later, I was on the cover. Too bad it wasn't the other way around on both counts.

BOSTON PROMOTION DEBACLE

One of my first Playboy promotions was a car show in Boston. At that time all the Playmates were required to wear spandex outfits. There was no way in hell I was going to wear Spandex – ever, PERIOD. I told the Playmate promotions director, who at that time was Valerie Cragin, that I would wear leathers and a tight angora sweater, but no way was I going to wear spandex.

We get to Boston and it is a huge car show, and we did a lot of those in the 80's. I was rooming with Connie Brighten. We were sitting in the room and on one side of me was Kym Herrin and on the other side Cathy St. George. I remember Kym asking me, "How did you get out of wearing this outfit?" I just responded, "I couldn't fit into it, and there was no fucking way I was going to wear it anyway."

Kym was always like an angel, she was beautiful and her spirit was contagious. Cathy and I were the supposed "bad girls." So, after the car show Cathy and I decided to go out and visit some friends. I can't remember whether they were fans or friends, but we wanted to go out and have fun. We had them pick us up and we went out to have a good time. We got back around three in the morning and headed to our rooms.

The next morning Valerie came down on us saying she sighted us doing heroin in the cab back to the hotel. I just flipped; she had it in for me because I would not conform, and she dragged Cathy into it as well. I have never and will never stick a needle in my arm. She was so off-base and vindictive. She told me I would never do PM promotions again.

I went to Mary O'Connor and just told her the truth. I never again dealt with Valerie, and she resigned soon afterwards, and Cathy and I were vindicated. I am not a conformist and never will be.

PLAYMATE OLYMPICS

One of the best times I ever had at the Playboy Mansion in LA was when they started the Playmate Olympics. It was the first time and there were four different teams of four Playmates each. Monique St. Pierre (Miss November 1978 and Playmate of the Year for 1979) was captain of our team, which included Kym Herrin (Miss March 1981) and Gig Gangle (Miss January 1980) and me.

Talk about a party! We were laughing, giggling and partying from the get-go. We had to do these events that were ridiculous and looked hilarious, all hosted by Chuck Woolery. The four of us would gather before the events and try to decide who was doing what in between partying and wearing these ridiculously small bikinis. I remember that most of the time we were so hyped-up, and laughing so hard, we couldn't do the games. I think our team finished dead last. But through the two days of competition, Monique, Kym, Gig and I became very close and many pictures that ended up in Playboy showed our camaraderie. Victoria Cooke's team (Miss August 1980) was unbelievably competitive and would do anything to win. They did win, but I couldn't take anything so seriously where either I or someone else was always losing a top or a bottom, or were smeared in baby oil or some kind of greasy liquid.

At the end of the competition, some of us were asked if we wanted to go up in the Goodyear blimp. I jumped at the offer. Big mistake! It was terrifying! It takes off going straight up and nose forward to the sky and cruises at smog level. I choked, gasped and begged to be taken down.

It was also during this event that I became very good friends with Karen Witter, Miss March 1982. There were a bunch of us in the great hall of the mansion and Kareem Abdul Jabbar walked in. He stood right behind me and the next thing I know

this darling little Cheryl Tiegs-lookalike walked up to him and seductively said, "I just love Ka-reem!!" emphasizing Kareem like cream. Karen was only maybe five-foot-four and she only came up to Kareem's crotch. I looked at her, then at him and he just smiled as I picked my jaw up from the floor and started hysterically cracking up. From then on, I always loved Karen and her distinctive sense of humor.

PLAYMATE VIDEO

When Playboy asked me to shoot a Playmate Video, I did not know what to think because they had never done one before. For that matter, what was a video? At the time, I was dating Gary Fencik of the Chicago Bears, and he was a fairly conservative guy. The Bears and Coach Ditka had pinned my Centerfold to the chalkboard that they used for practice. When they started talking about Gary's position on the team, they flipped the board over and there I was, in all my glory. He was embarrassed and then all the radio stations started in about us....

I told Playboy I would have to talk to Gary and think about it. Videos were not in my contract with Playboy, so I had the option of declining. Details about the content of the video were also sketchy, adding to my apprehension. These were untested, very early days of video for Playboy. I talked it over with Gary and he worried that it might be pornographic and distasteful. But since we had nothing to base our opinions on, how did we know what the final cut would look like? Playboy was telling me it would be very tasteful and they would pay me a whopping three hundred and fifty dollars. I told Playboy "NO!"

Playboy was not at all happy with my decision. In fact, they were angry as hell. I was told in so many words that my career would be ruined and my running for Playmate of the Year was over and out of the question. Being so young and contemplating my future at the time, I took my time to talk to lawyers and friends. Vicki Chiconis was right.

I had been propositioned by the Senior Photography editor Gary Cole: he told me that I would be Playmate of the Year, and again and again he would ask me to lunch at the Cape Cod

restaurant and booked a room at the Drake Hotel. I always made up excuses to get out of the "situation." He assured me that the video was the right thing to do. I blindly set myself up.

The video was shot in the Playboy mansion in Chicago and it turned out to be the last time a Playmate was shot there. I was extremely tense through the entire shoot, feeling rather compromised and exploited. The video went Platinum and Playboy made a ton of money. And Gary Fencik—we broke up over the video!!

LEE WOLFBERG

I had been staying at the mansion in Los Angeles for a few months when I met a man who was one of Hef's cronies. Up to this point I had never "entertained" anyone there and I did not find most of the celebrities my cup of tea, especially Bill Cosby, which is another story in itself. I always felt they were salivating and pictured me as a piece of candy. So, when I was sitting around talking and slowly becoming friends with Lee Wolfberg, I felt comfortable. He asked me out to dinner and I agreed to go, knowing on my end how platonic it would remain. It was only dinner.

When you're a Playmate and one of the guests ask you out to dinner, it has to be cleared with the powers to be. I assumed this had already been done for my dinner with Lee Wolfberg. Lee asked me to take a cab over to his condo on Wilshire Boulevard and we would go on from there. This was my first sign: I should have known this dinner had not been cleared by Playboy when he didn't want to pick me up.

When I arrived at his condo, I walked in and, to my total surprise there were four other women there. Lee told me we would be meeting some people at the nightclub we were going to, and I remember it was owned by Hef, so I thought *Okay, a public place. No problem.* But a nervous gut-feeling was kicking in because Lee had never mentioned this to me.

We drove away in his Bentley and arrived at the nightclub. We walked into the nightclub and were escorted to a table where five older men were waiting for us. Everyone was spread out and

we were placed between these men. My whole defense system was screeching ALERT! One man next to me had a bad toupée, fatter than a pumpkin and extremely vulgar. He put his arm around me and tried to pull me into him. I wiggled out of his clammy hold and started to panic as Lee says, "Well, girls, I will leave you here to have a good time with these gentlemen, and they will escort you home later."

I jumped up and said, "Oh, no you don't, Lee. I will leave with you now!" He turns red and I can see he is embarrassed and angry, but I don't give a damn. He turned and started walking to his car as I followed him out of the nightclub. As soon as we are outside he started yelling at me for embarrassing him in front of friends and clients. Once we got into his car, I lost it and started screaming at him to take me home, and if he ever thought he was going to pimp me out, he had another think coming.

I never spoke to him again when I saw him at the Mansion, and every time I did see him I would just sneer at him and give him a dirty look. He always cowered and seemed to run away from me. I tried to get him kicked out of the mansion, but to no avail. Later I learned he was the agent for Don Adams and a number of Hollywood celebrities who came to the mansion and thought that every girl was there for their sexual satisfaction. So, young Playmates: beware! Lee Wolfberg is dead, but there a dozen more just like him at the Mansion.

DA' BEARS

The whole time I was with Gary, I would go to the games and became acquainted with the other women who were married to or dating a Chicago Bear. I would park underneath and get the team a six-foot hoagie cut up so they could munch when they were coming to their cars. "Mongo" always ate his weight and it was usually gone. Then we would all go out, mostly to a friend's who was supposedly an electrician, but was also a big coke dealer on the side. We would party all night and get home after dawn. It was amazing how much these guys partied. Many times, a few of the guys couldn't drive home afterward, so they came to my apartment and crashed. That was a sight – waking

up to find three Bears players crashed all over our living room.

HOWARD COSELL

Gary and I went to the Kentucky Derby in 1983 and stayed with his friends just outside the track. We partied like it was 1999. The day of the Derby we had VIP passes and went up to the VIP booth. There were many celebs there, and when we walked in, everyone looked at us. I felt like a piece of meat. We walked to a table where Howard Cosell was sitting. He looked at me, and I felt like he was going to eat me, almost salivating. He said, in his very unique voice, "Come over and sit with, on, me." Gary gave me a look like *go ahead,* kind of chuckling.

I went over and Howard grabbed me and planted me right on his lap. I felt so uncomfortable as he was talking and bouncing me on his lap. I looked at Gary in total horror and he just laughed; he knew I could take care of myself. After about five minutes, Howard started to put his hands on my butt and then higher with every minute. I finally looked at him and said, "Howard, you go any further groping me and I'll break your hands." He laughed and I jumped up and slapped him, which brought on a roar of laughter from the whole crowd. I laughed and walked away: I needed a shower and a delousing.

BEASTIALTY

One day I came out of the Playboy Mansion bathhouse to go swimming, topless and just hanging out. I saw a crowd toward the koi pond. I looked and people were cheering and I wanted to know what the heck was happening. I walked over looked at what I never want to look at again: there was a woman giving one of Hef's dogs a blow job. I was disgusted, but at the same time I kept watching, as we all do. The woman was a porno star proving her prowess to even the most basic animal. She swallowed and everyone cheered, but I thought I was going to throw up. GAG!

THE PORNO STAR AND
HIS GIRLFRIEND

The bath house in the Playboy Mansion in LA had a great tanning bed. There were always people walking in and out naked or topless, but no one cared. This was the Mansion.

Early one night I was waiting to go under the rays, lying on one of the huge pillows and just hanging around. There was a couple in the tanning bed and they were giggling and carrying on. I really wasn't listening, but then I started to get bored, so I started eavesdropping. She is going on about how excited she was to be in his movies and how happy she is and how she was going to be a star in Hollywood. I couldn't tell who they were, so I became very curious. Their time finally ended, the lights went on and she climbed out. I didn't know who she was, but she had an incredible body and was still giggling and cooing at him. I looked at him and immediately realized it was Harry Reems, the most famous porno star of the time. Now I was really curious!

He decided to stay under longer while she took a shower, and he asked me if I'd like to share the tanning bed. I said "Sure" and jumped in on the other side. Remember, everyone is very cool at the mansion. No one was going to attack you, or at least that's what I thought. I kept saying to myself, *Does she even know what he does for a living?*

After her shower she started dressing and putting on black garters. She came back over to the tanning bed and stuck her naked butt under the lamps and asked Harry to fasten her back garter. I looked over and everything "pink" is staring me in the eye!! Harry started caressing her and looked over at me and asks "Would you like to join us?" Without saying a word I just lay back down and closed my eyes. I was just horrified to see that they just had cunnilingus in front of me and that she was so young.

After their brief interlude, she left and Harry started telling me the story about how he met her and how he immediately put her as his leading lady, even though she had no experience. She could not have been more than 18, and they had instantly fallen in love and were planning on getting married. The whole

time I was watching this charade, I couldn't help but wonder what happens if she falls for another leading man or Harry falls for another leading woman. I wonder what they will tell their wonderful children.

It wasn't too long afterwards that Carrie Leigh became Hef's girlfriend and she had the entire bath house transformed into a workout room. Who knows what happened on the bar bells!

MISS BUDWEISER

In 1983 I was asked to be the first Miss Budweiser. I would tour all over the country and represent Budweiser at the largest distributors and college spring breaks. I had a chaperone and everywhere we went I had a condo. On most of these tours I judged crazy spring-break contests at events from Massachusetts to South Padre Island to Daytona Beach. At the end of two weeks, the beach band Jan and Dean would come and do a concert on the beach and I would introduce them. They were all very cool, except Dean was married to one of the marketing VPs from Budweiser. Well, he liked to have young women parade in front of him in lingerie, and he got caught. It was very messy. Jan was always an asshole, and he could barely verbalize anything because of the accident on Mulholland Drive: he was just a tormented, angry person and physically handicapped. So they would come in at the end of these huge spring breaks that I had been working.

We had to finally put water in my Budweiser bottles because I was drinking non-stop and I felt like I was drunk all the time. The water helped. I got to sit with the Busch family in the 1983 World Series and watch the Cardinals win. It was an exciting time. I had to go through brew school where I learned about the brewing process, in case I was asked about how the beer is made or about its ingredients. The stables with the Clydesdales were so immaculate, and the Dalmatians were running around. I thought I want to come back in the afterlife as a Clydesdale or one of the dogs. They were so well taken care of.

There was a foreboding message ahead. I had no idea that one of the company VPs would try to woo me and then take me

as hostage, tie me down like a dog and beat me with a chain. I escaped, took his car keys and started home. A police officer stopped me as I drove in this pervert's car, because he recognized me as a Playmate. I was furious that he had stopped me, but told him my story. He was kind and helped me to get to the airport. This was very harrowing for me. The next year with Budweiser was very difficult. All that glitters....

ENZO FERRARI AND MY FORMULA 1 DAYS

I met a Formula 1 racing driver when I went to Europe with an ex-boyfriend. He drove for Ferrari and I met him in Belgium at the Francorchamps track. He was Swedish, and after I met him he pined for me.

Almost a year after I met him, I went to a skiing event held for the drivers in Sestriere, Italy. I stayed in Italy, and after a year we went to Fiorano, Italy where I was to meet Enzo Ferrari. I had met all the crew, was always in the pits and met celebrities attending the races. Formula 1 is quite "Jet Set:" I met George Harrison, who was keen on me; Eric Clapton, a gentleman; and many Royals. We had a flat in London, one in Monte Carlo, a house in Sweden, and a very private house in Cap d'Antibes.

The first time I met Enzo, Stephan had gone to the track to look over the car and I was just moseying around. I went up to the offices and was looking around when I heard a voice, "Comme." I turned to see this very old man with a walking cane, looking at me. I had no idea he was Enzo. I walked over and tried to help him, and then these handlers came out and tried to whisk him away. He looked at me, winked, and went to pinch my butt – Italian through and through. I was astounded when I found out who he was, and secretly felt lucky that I had a moment with the Great Enzo.

The second time I met him was when we were invited to lunch at the Ferrari offices after Stefan had gone to look at the new design on a car. Michele Alboreto was the No. 1 driver for Ferrari, a great guy. There had been rumors of an affair between Michele and me: the Italian press were just causing drama. We had gone to lunch with Enzo and his sons, and there was a huge

table with about twelve of us. After five courses, Enzo motioned
for me to come to him at the head of the table. I was not really
prepared, but I walked over, knowing he spoke very little English
and I had practically no Italian. He had long, thin, hard hands
and he spoke in Italian to one of the servers to pour some grappa,
a strong liqueur. He motioned for me to sit, not on a chair but on
his lap. I looked at Stefan and he was giggling and motioned for
me to go for it. I sat on Enzo's lap, we all drank a couple of shots
of grappa and he was laughing; everyone was. Enzo then started
groping me up further and further. He had a strong grip on me.
I looked at Stefan who just laughed. I looked at Enzo, kissed him
on the cheek, and pushed his hand down. I went to get up and the
old fart pinched me on my ass. I jumped and everyone laughed.
He was truly a sneaky and very powerful man.

Charlotte Kemp was born on January 27 in Omaha, Nebraska. Besides her Centerfold, Ms. Kemp appeared on the cover of the October 1983 Playboy magazine. She went on to be in over 20 movies including "Risky Business", "Repossessed" and "Frankenhooker". She became the only Playmate granted a license by Playboy for the "Playboy Running Team" which also featured 10 other Centerfolds. She has compiled all these stories for over 20 years. Her son is her best production ever!! Her first book "For My Eyes Only" is still in publication and she continues to write books, poetry, short stories and screenplays. She is now married and lives in Texas.

Judy Tyler–
Miss January 1966

CASTING COUCH CREEP

It seemed so innocent at the time. I was only 18. After posing for *Playboy*, I wanted to find out if I could have some kind of career in modeling. A dear friend had me over to dinner and introduced me to an agent. It all seemed so glamorous and innocent. My friend was a famous photographer, and the agent had an office on Sunset Boulevard in Hollywood. What was more natural than meeting him in his office? "For a look-see", he said.

When I arrived it didn't seem strange that his secretary was out, or that he closed the door to his office when he invited me in. I can't believe I was so naïve! Of course, he knew what he was doing and how to approach me. I often wonder how many young girls he lured into that office with promises he never meant to keep.

At first he was very professional, asking me to stand next to the window so he could get a good look at my face. He had me make all kinds of facial expressions—some pretty weird—saying he wanted to see how expressive I could be. He kept getting closer and closer to me until I could feel his breath on the back of my neck. He asked me to take my top off. I was surprised, but not entirely shocked. After all, he knew I was a Playboy Centerfold. I asked him if we really needed to do that. He stepped away and looked disappointed saying, "Well, if you're not sure of yourself here with me, then how you are going to be when the money is on the line? I just don't know."

I felt guilty that I had doubted him, so I took off my blouse. "Turn around," he whispered, and again he began to move closer to me. "You really are beautiful, "he said. Such a flatterer! He reached out and touched my stomach. "That's good. Nice and flat. Now I think I had better see your breasts." I'm not sure if I blushed or not, but I know I wasn't sure if this was the way things normally went. I did know I didn't want to make him mad. I thought, *What the hell,* and took off my bra.

I heard him suck in his breath as he looked at my breasts. He walked around me, not saying a word, just looking. It felt creepy, but still didn't want to mess up my chance with him. And then, when he was behind me, way too close, I felt him brush up against my ass and there was no doubt about what was going on in his pants. That's when I knew what he had in mind—and it wasn't going to happen. I pushed him away, grabbed my clothes and headed out the door. He didn't try and stop me, which was good for him. So I didn't get a job or an agent, but I did get an education!

Judy Tyler was born on December 24, 1947 in Los Angeles. After her Centerfold she went into sales and later combined her deep interests in art and music by creating Fronds by Judea, original art made from palm trees, and promoting the reggae group, Krooshal Force. Judy Tyler died from complications of open heart surgery on June 18, 2013.

Dede Lind –
Miss August 1967

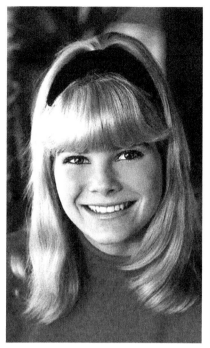 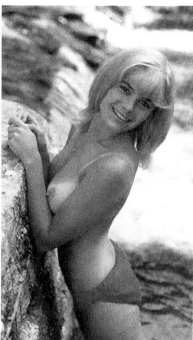

 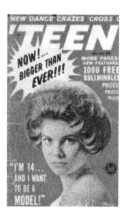

All photos used with permission by Dede Lind

MY FIRST MODELING JOBS

I first started modeling when I was 14 years old, and I was on the cover of *Teen* magazine twice in one year: May 1962 and October 1962. The only other model who had been on the cover twice in a year was Cheryl Tiegs. I was no Cheryl Tiegs, but I was very proud of myself. I had always wanted to be on the cover of *Playboy*, but I just wasn't old enough. I was on the *Movie* magazine with Johnny Crawford, with all the *Leave it to Beaver* cast and in *True Romance*, *Secrets*, and *The Dude* magazine. I did a lot of work before Playboy, during Playboy and after Playboy. I was on the cover of a bunch of European magazines and the photographer was Bernard of Hollywood. He's the father of Sue Bernard who was a Playmate in December 1966. He photographed Marilyn Monroe and a few other Playmates.

BECOMING A PLAYMATE

I had saved a Playboy cover, and when I turned 17 a friend shot pictures of me and took them to Playboy photographer Mario Casilli. Casilli said, come back when she's 18. So when I turned 18, I went back and tested for the cover and ended up being Miss August 1967. I didn't get on the cover of Playboy until the February 1968 issue, a Playmate Review issue, and my Centerfold appeared on the cover along with a few other Playmates

TO THE MOON

In my second Playmate Calendar shot, November 1969, Astronaut Richard Gordon, unbeknownst to him, took my picture to the moon aboard the *Yankee Clipper*. I had no idea that I was taken to the moon until many years later. Gordon's fellow astronaut had put my picture in the cockpit, and Gordon did not even know. I was a stowaway. He had me to look at while he was remembering home. What a shot!! When I found out

years later, he auctioned off the picture and we both signed it. It went for over seventeen thousand dollars.

CELEBRITY SLEUTH, CYNTHIA Myers, STEVE SULLIVAN

I was the first Playmate to be in the magazine *Celebrity Sleuth*, and continued to be in the magazine more than any other girls. I designed all my layouts in every issue. Then I got into the mail-order business with Cynthia Myers with *Glamour Girls, Then and Now* with Steve Sullivan, and we all helped each other out. That's how I started my business with autographs and fan base.

I have a dream that Cynthia and I are at Glamourcon together and we're working and having fun. I dream about her. In my dream I say, "Cynthia, you have to go back now." She then says, "I know." She leaves and I wake up. It's such a beautiful dream. I feel like I was really with her, and I know I was because I was obviously out-of-body with her; I believe that dream. It's always a pleasant dream when you dream of someone you cared so much about.

Dede Lind was born on April 15, 1947 in Los Angeles. Dede began modeling at the age of 14. She graced the cover of Teen magazine and was soon noticed for television appearing on The Donna Reed Show and Leave It To Beaver. At age 19, she was photographed by Mario Casilli for Playboy who knew she was married and separated from her husband and had a baby at the time of her Playmate shooting. She needed the money to support her son. Dede has received more fan mail than other Playmate in the history of Playboy. She lives in Florida, and to this day she is a close and beloved friend of mine.

Reagan Wilson –
Miss October 1967

All photos used with permission by Reagan Wilson

ENTERTAINING THE TROOPS

When I became a Playmate in October 1967, it was during the Vietnam War. The country was embroiled in war protest movements and the Playmates were the pin-up girls of the servicemen. They carried us into battle, wrote to us as if we were the girls they left behind, their friends or sisters. We were the same age as the soldiers, in our late teens to early 20s. When I became a Playmate we were very much in demand across the country to do promotions for advertisers in Playboy magazine, such as Ford and Levi's, and at military bases to entertain the troops. I was 21 at the time that I started doing the promotions and, as I look back, I'm amazed at how mature I had to be.

Most of the promotions were hard work, and after a while I took it as a way of life. I would leave Los Angeles every few weeks, fly first-class to a city I had never been to before, be met at the airport and taken to the best hotel, and then work like a demon signing pictures or appearing at conventions. The money was very good, about one hundred dollars a day, which is like five hundred a day today. I was an up-and-coming actress, so the Playboy promotions gave me the freedom to promote my acting career. With my Centerfold money, I bought a 1968 Ford Mustang with white bucket seats and painted orange, my favorite color. I loved driving down Sunset Boulevard in Los Angeles with all my *Make Love Not War* stickers and the great music from that era. I was able to move into a very nice apartment in West Hollywood, close to my acting classes and auditions. I furnished the apartment with an old steamer trunk that reminded me of an old movie with Lauren Bacall, my favorite actress, as well as some very nice furniture from High Point, North Carolina that I received at cost from doing promotions there. Hef had just moved from Chicago to Los Angeles and the Playboy Club was in full swing, which was really glamorous, as were the other beautiful clubs and restaurants in Los Angeles such as the Brown Derby, Cyrano's and Scandia. I found the parties at the Playboy Mansion boring and would usually bring my father as my date. Hef was always a gracious host and the Mansion was certainly

beautiful, but I wasn't into a lot of the guys who hung around trying to score.

When people hear you were a Playboy Playmate they always think of drugs and wild parties. My experience at the Mansion was very low-key. Hef drank nothing but Pepsi, never did drugs, and neither did any of the people I knew. I was very close to Dee Dante, the head of Playboy Promotions, and her husband, John Dante, an executive with Playboy. Dee and I became good friends and she booked me on numerous promotions. When I broke my arm in an accident, she had money advanced to me from Playboy for the medical bills. Besides being a good friend, Dee was very elegant and spiritual woman. After I left Los Angeles and moved to New York City, I heard that Dee and John had divorced and she had become a nun. Wherever she is, I love her.

The most heartbreaking and terrifying experiences I ever had involved visiting the wounded from Vietnam at a burn center in San Antonio, Texas. I had been to dozens of military bases to sign pictures, but my visit at this hospital was something that made me even more of an anti-war dove. I have several pictures of me smiling and talking to a handsome young soldier whose legs had been amputated. I spent time in a ward with a boy whose entire body was burned. His mother was there and she was pleading with her eyes for me not to show the horror I felt. She was so brave and so I had to be, too. I saw men who had less than a year to live and were making jokes and being so upbeat with me, telling me how much the Playmates meant to them. After a while, I had to tell Dee Dante I just could not go to another hospital for the seriously wounded. When I saw the scene in the movie *Patton* when the general, played by George C. Scott, berates the soldier for crying, I went totally into shock. War is hell! I've spoken to people who say we have to defend ourselves against the Communists, or whoever. To me, war are those maimed kids and their families I met.

PLAYMATES ON THE MOON

It was November 19, 1969 and Apollo 12 was racing around the moon with its crew comprised of Mission Commander Pete

Conrad, Command Module Pilot Dick Gordon and Lunar Module Pilot Alan Bean. While Dick Gordon orbited the *Yankee Clipper* 60 miles above the moon's surface, Pete Conrad and Alan Bean were walking over the moon's surface. As they were picking up rock samples and checking their cuff checklists, they both started laughing so hard that the people back on earth thought they were drunk. What was the cause of their merriment? It was a picture of Miss September Angela Dorian on Alan Bean's cuff list and yours truly, Miss October 1967, on Pete Conrad's cuff list. Pete Conrad later said it was a gag: Engineer and Pad Leader Guenter Wendt, and other members of the crew, were always doing something humorous to their checklists. In this case, they had gotten the 1970 Playboy Calendar off a newsstand and had the pictures printed on fireproof plastic-coated paper. Now, when my husband Barry says I'm a space cadet, I always say, "Of course I am. I have been to the moon!"

THEY SHOOT BUNNIES, DON'T THEY?

One experience I still have nightmares about was in San Antonio, Texas. I had been selected by the city fathers of San Antonio to be in their annual parade float, which was a very big society event. I was dressed in a bunny costume and riding on the float with the leading members of San Antonio's founding fathers. I had to stand in my high heels and throw candy to the kids watching the parade. It sounds like fun, but I was scared to death because I was on a six-foot-high, narrow pedestal bouncing up and down and swaying from side to side as it went down the road. They did not give me enough candy and when I ran out, the mainly Hispanic viewers starting yelling and screaming at me in Spanish. It seemed like I was on this float forever! When the parade route finally ended, there were a number of policemen waiting for me. One of them came up to me and said, "We sure are glad you're still alive!" I asked him what he meant and he said they had received death threats from a number of men who said they were going to "shoot the goddamn bunny!" I had been on a local TV station the night before and expressed my protest of the war, and the station had been getting a lot of

threatening calls over my political views, including the death threats. I was furious I had not been notified and taken off the parade. I couldn't wait to get out of San Antonio and back to California.

THE HONG KONG SHIPPING MAGNATE

When you become a Playmate all your fan letters are sent to Playboy and any weird letters or requests are not forwarded to you. I received one letter from a Hong Kong shipping magnate that Playboy decided to forward. I guess they figured I could make up my own mind. The writer sent me a two-page typed letter comparing my breasts to beautiful white mountains, and my nipples to perfect red cherry blossoms on snow. He requested if I would fly to Hong Kong as his guest and spend some time with him, he would put five hundred thousand dollars in American money in any bank of my choice in any country of my choice. Needless to say, I never took him up on his offer. I was never for sale at any price.

Reagan Wilson was born on March 6, 1947 in Torrance, California. Reagan grew up mostly in Missoula, Montana and studied journalism at Montana State University. She has appeared in numerous television shows, including The Big Valley, The Beverly Hillbillies, The Carol Burnett Show and The Big Valley. She now lives in Santa Monica, California with her husband, Barr,y where they own the Topanga Rug Company.

Nancy Harwood –
Miss February 1968

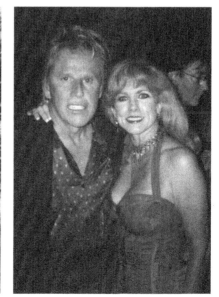

All photos used with permission by Nancy Harwood

AS SEEN ON TV

In 1979, I was living in Glendale, California. I was at a point in my life where I had given up on men. I had made up my mind that there was never going to be a man out there who had been through everything I had, and would understand and not make me feel wrong for it. I decided that I was going to be a career-oriented woman and was going to be wined-and-dined for the rest of my life.

At the time I was dating about five different men and having a wonderful time. I was also training to run a full marathon. The gentleman who was helping me prepare was in involved in the The Hunger Project. The purpose of the The Hunger Project was to end starvation on the planet by the year 1997. I would go to Venice Beach and enroll people to fast one day a week and sign a card committing to end world hunger. The cards would go to the chairperson in that area. The Hunger Project still exists and works extensively in Third World nations.

My other day job was with Levi Strauss & Co. I was the supervisor for the Missy Marketing Division. After work one evening, I had a blind date, and we went to Galley Restaurant in Santa Monica for dinner and shot pool afterwards for a couple of hours. When it was time to go home, I dropped him at his car and then made a wrong turn. As soon as I got on the freeway, I realized I should get off at the upcoming off-ramp. I went from the first lane to the second lane, from the second lane back to the first lane, and a police officer saw this and pulled me over and gave me a ticket.

The next morning, I was putting on my makeup and getting ready to go to work; *Today in LA* was on TV and they were talking about The Hunger Project. I interrupted my makeup, ran into the living room to see what I was hearing. Of the panel of four speakers, one person stood out: a gentleman with thick brown hair wearing a blue three-piece suit. I saw him only from the side. I was ecstatic listening to them. I went back to the bathroom and finished my makeup, still listening to the program. Questions like "What do think about love?" were being asked.

The reply was so intelligent and sincere. I ran back into the

living room and saw that the responder was the gentleman in the blue suit. I said out loud, "Why can't I meet a man like this?" A man with wit and direction, goals, and still some virtue within, instead of the lackluster suitors I was dating. I can remember musing that I wanted to marry him and then grumbling to myself that his type was probably was already married with three kids. I turned off the TV and went to work.

The next day in court for my traffic ticket, my name was called; As I walked up to face the judge, I glanced over and I saw four attorneys with their clients. One of the attorneys I thought was very good-looking. I could feel his eyes undressing me. The judge asked me what my plea was and I replied, "Not Guilty."

The judge gave me two weeks to find an attorney. As I left the courthouse and walked to my car, a gentleman in a cream-colored suit was calling to me, waving a white slip of paper. I thought I had dropped something out of my handbag. As he came running towards me I noticed he was the same good-looking attorney in the courtroom. He asked me if I had an attorney to represent me. I replied, "No not yet." He said he would represent me, and when I asked him what his rate was, he told me he would represent me for two hundred dollars because he thought I was a pretty lady. I couldn't believe it! He gave me his card and told me to come see him the next day.

I waited two days before I called his office. He had the penthouse suite. He sat in his black chair and questioned me about my ticket. He also asked what I did when I wasn't working for Levi Strauss. I didn't know what to say. Wracking my brain for a few seconds I replied, "Oh, I was involved in The Hunger Project."

He looked at me very strangely, I noticed, and said, "Tell me about The Hunger Project." So for about five minutes I told him about the project, not really hearing what I was saying. All of a sudden he stopped me and looked me squarely in the eyes and said, "Do you know who I am?"

I thought, *Oh no, here comes the bullshitter of the universe.* I had heard rumors about attorneys before, although I never dated one. I said, "Your name is Mike Kelly."

"Yes, that is correct, but my full name is John Michael Kelly and I am the Chairman of the Board of Southern California for

The Hunger Project."

I took a really long look at him. My heart started to pound and I realized, *Oh my God, this is the man I saw on TV!* I couldn't believe my eyes. I jumped out of the chair and practically screamed at him, "You're the man I saw on TV with The Hunger Project."

He probably thought he had just let in the wildest woman of the century. I composed myself and sat back in the chair facing his desk.

Michael and I started dating. Underneath the flagpole at the Jonathon Club at the beach on July 4, 1979, he told me that he knew I was dating other guys but that he was going to commit to me. *Commit to me.* Now that was a line I had never heard from any man's mouth.

As time went by, I stopped seeing the other gentlemen. Every time Michael spoke to me, it had validity and I listened. He spoke with a security in his voice and I felt a safe place within him. We were married on April 13, 1980 at Wayfarers Chapel in Palos Verdes.

When I look back and realize I had married the man I wished for and I had first seen him on TV, I just can't believe it. The Lord works in mysterious ways. If you allow the universe to work for you, I guarantee you will have miracles in your life – and fairy tales do come true.

Nancy Harwood was born on December 17, 1948 and passed in May 2014. She graced the pages of Playboy in February 1968. She is missed so much by all who knew and loved her. She was always the "Light" in any room.

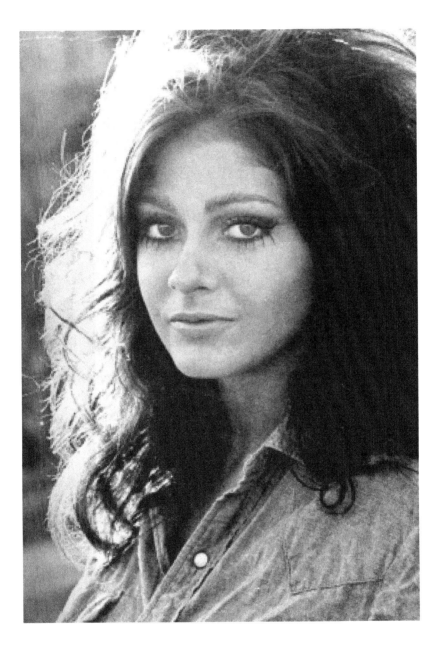

Cynthia Myers –
Miss December 1968

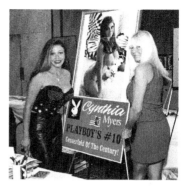
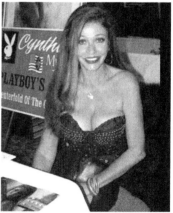

All photos used with permission by Cynthia Myers

RIOTS AND CELEBRITIES

Many wonderful and exciting things happen when you become a Playboy Playmate, and those things tend to happen very quickly. My arrival at the Playboy Mansion in 1968 occurred during turbulent times, specifically, the beginning of the 1968 Democratic National Convention in Chicago. There were very important people and celebrities in and around Chicago at that time, and many were either staying at the Mansion or were frequent visitors.

Adlai Stevenson, Jr., Warren Beatty, Art Buchwald, Richard Schickle, Sammy Davis, Jr., George Plimpton, Jack Valenti, Eddie Fisher, and many others, from Bill Cosby to Tiny Tim to George Jones. It was all quite a spectacle for a 17-year-old girl who literally had just completed graduation and cleaned out her high school locker in Toledo, Ohio prior to being presented with three dozen red roses on arrival at the Chicago airport and whisked away in a sleek, black limousine.

Can you imagine this diverse group and hundreds of beautiful Playmates and Bunnies sashaying through the Chicago Mansion and in the underground pool, waterfall and sauna? It was a spectacle to behold! I only wish I had been worldlier. I could barely hold a political conversation with George Plimpton and Adlai Stevenson. So I just tried to take it all in.

I do remember one thing that I thought was cruel and deceiving: many of these men with connections and power were taking advantage of the many ladies by offering them bogus promises of movie roles, agents, television roles and the like. And we all know why they did it! Many of the girls were just like me—17 years old and clueless in the ways of powerful men. It certainly wasn't a fair seduction!

And on the night of the riot in Chicago, Hef had been watching the minute-by-minute live news coverage on television. He decided he wanted to get a closer look and go out and experience it himself – an extremely rare occurrence, as Hef rarely ventured outside the Mansion in those days. Not long after leaving the Mansion, he was whisked back in among bodyguards while his personal attendants ran around the Mansion in complete

disarray. Hef had gotten too close to the action and had received a very severe blow to the head.

THE LESBIAN SCENE

After my Centerfold came out, I became a regular on the *Playboy After Dark* television show. It was so much fun, and Hef was always there if you needed him for advice or just old-fashioned moral support. He always tried to protect all the girls the best way he could. He never wanted to see any of us hurt. Hef felt responsible for us in many ways, knowing that many of the girls were way out of their element, especially at our tender, naïve ages.

In 1969 I was told that Russ Meyer, "the King of Nudes," had seen me on *Playboy After Dark* and wanted me for a screen test for his upcoming film, *Beyond the Valley of the Dolls*. This was his new film he had co-authored with the famed movie critic, Roger Ebert, and "The King of Nudes" had just received *carte blanche* from Richard Zanuck at 20th Century Fox Studios. I certainly didn't object to a starring role in a major movie studio production, but I was a nervous wreck as I had never really acted before. (The television show was just "me being me"!) So I hired a private acting coach, since I didn't have clue to approaching and carrying a role by myself.

The zinger to this role was that I was to have a lesbian love affair with Erica Gavin, who was the star of Russ Meyer's famed film, *Vixen*. Erica and I became friends and I was hoping that she, being more experienced from her acclaimed sex scenarios in *Vixen*, would take the "aggressive" role. I had to do this "dance" and I was hoping she would lead. Erica was nervous throughout the film, too, and Russ Meyer was furious because she had become anorexic. Russ Meyer kept asking me to try to persuade Erica to put "some meat on her bones." Erica and I would visit after rehearsals, and I was glad that we could get to know each other before our scenes were to be filmed. It didn't take long for me to realize that Erica was terrified of Russ Meyer. I felt so badly for her. She told me stories of how Russ had confined her to a cabin in the Canadian woods, along with him and the crew,

for the filming of *Vixen*. Russ Meyer is a tyrant in his own way and I knew she wasn't lying. He had complete control of her and she had been completely isolated.

Now I was trying to do my best in my first major Hollywood film. My lesbian scenes with Erica were quickly approaching and I worried about what my family would think back in conservative Ohio. I came from a repressed, but loving, Methodist family that did not even have the word *sex* in their vocabulary. Sweet Jesus, now that I think about it, they didn't even say the word *pregnant*. They embraced the more delicate phrase "in the family way".

Rumors had been circulating on the set that Erica actually was a lesbian, and a certain lesbian actress in the film pursued her constantly. Whether Erica was a lesbian did not interest me. I liked her. She had been used and abused and I felt sorry for her. She was a good woman and successful on screen. She was *Vixen,* and that movie with Erica's unforgettable performance put Russ Meyer on the map and made him a millionaire. During all this tension on the set with Erica, the lesbian, and Russ, I was just trying to do a good job so I could have a career in the crazy movie business. It was way too late to go to back to Toledo.

At the time, I was dating a well-known actor. During a discussion about my upcoming love scene with Erica, he asked me how comfortable I was with Erica and the scene. I told him I did not have any problems with it and I just wanted it to be believable and very sensuous. He asked me "Do you think you would be comfortable enough to have an orgasm?" I thought for a moment and answered "Yes." After that conversation I just relaxed and forgot about everyone else's idiosyncrasies and just concentrated on my role and my first on-screen orgasm.

The scene turned out beautiful and *Beyond the Valley of the Dolls* was huge success. It quickly attained cult status and to this day is shown on cable television periodically and in art film houses. I still receive many fan letters and requests for film memorabilia. If it had not been for my Playboy Centerfold exposure, Russ Meyer's millions of fans would have never known who I was.

But on a sad note, after filming was completed Erica had a nervous breakdown. She told me later that her father had come to visit and she didn't even recognize him. And a few years

later, the lesbian scene cost me my engagement to a prominent physician. I had suggested we go see *Dolls* when it was playing at a Hollywood theater. He was okay with everything up to where Erica and I made love. After the movie, he looked at me and said, "Cynthia, I know how you look and act when you have an orgasm, and you had one with that woman in the movie!" I couldn't deny it, nor did I want to. He couldn't deal with it. That was his problem, but the engagement was over. Years later he apologized for being so silly and immature, but it was too late. I never go back. It's a waste of time.

PORTRAITS OF VIETNAM

Soldiers of the Vietnam War will always hold a special place in my heart. They embraced me and I embraced them back. I received so much fan mail after my appearance in Playboy's December 1968 issue that I had to hire a temp to help me respond to all the letters. I answered 99% of their letters. I personally read and answered each one and I sent out thousands of autographed photographs.

One letter I received from a soldier was a "thank-you" for keeping him from being arrested in Vietnam. He went on to explain that he had kept his marijuana hidden behind my Centerfold pinned up on the wall of his hut. During a routine inspection, an MP was enamored with my photo and while centering his attention on it found the soldier's contraband. So they made a deal: the MP would ignore the "find" if he could have my Centerfold picture. The soldier went on to say he regretted the trade, but was very happy not be incarcerated.

Another soldier wrote:

> *Dear Cynthia,*
>
> *I was delighted to receive your personal reply to my letter. I told you of the wonderful effect that your '68 Playboy Centerfold had on the morale of us chopper pilots in Vietnam. Although in all truth, you had more than few of us banging our heads against the wall and*

muttering, "I've just GOT to get home!" I've
enclosed my money order for one of your
photos. I feel somewhat awkward doing it, as
if somehow peeking at a friend, and I shouldn't.
You were one of the rare bits of beauty that came
into our lives and I treasure that memory."

I also heard that my portraits had been collected by another ex-soldier named Doug Tracy, owner of *The Centerfold Shop* in San Diego, California. During his service in Vietnam, he had put my photos up all over his surroundings in the tunnels of Cu Chi where he worked as a tunnel rat. His duties included searching through the old underground trenches that the Viet Cong had used to sneak up on the French and were now using to fight the Americans. Doug left my nude photos pinned up everywhere, so they would be found by the enemy. It was his way of screwing with their minds.

I loved hearing stories like this, but along with a sense of pride, awe and gratitude to the soldiers, I feel a great deal of sympathy. The end of the Vietnam War wasn't like a victory for America. The soldiers deserved to come home and display their medals proudly, and they couldn't do that. It's impossible to imagine the torture they went through. They will always be in my heart, forever!

HUGH HEFNER AND BILL COSBY

Hugh Hefner is a very caring, sincere man. The thing that made me furious about the Mansion was that some guests would come in and try to take advantage of the women and Hef's hospitality. Many celebrities had a big problem with that. They thought gratuitous sex was owed to them, and that they were somehow doing YOU a favor. There were certain ignorant jerks who were guests and assumed the girls were there for their entertainment, as if we were a selection on a menu. Bill Cosby and Don Adams take first prize in the insolence category. My stomach still turns when I see Bill Cosby in his ads sitting with a bunch of youngsters pitching Jell-O pudding. I always

wondered if any of the Jell-O ad executives ever knew about his indiscretions. I saw firsthand how he would use drugs to have sex with women. I never shed a tear when I heard his son was murdered on the 405 in Los Angeles. I do feel very sorry for his son, but he paid with his life for the sins of his father.

Don't misunderstand; I had a wonderful time in those days. I wanted to do a fine job for Playboy and I was and still am very proud of being a Playmate. The *Playboy After Dark* shows were a great deal of fun and Hef seemed to be having a ball doing them. Morale was high and we were having a wonderful ride! Playboy was good to me and remains that way today. I will always treasure my friendship with Hef.

JAY SEBRING

One evening a small group of friends, including myself, were out with Hef. We were in Los Angeles at a popular disco. Someone mentioned that we were invited to Jay Sebring's home. I didn't know who Jay Sebring was, and I was told he was a very famous Hollywood hair stylist "to the stars" and that he owned Jean Harlow's old house. I adore stories of the Golden Era of Hollywood and the glamorous stars who reigned at that time, so I was thrilled to be able to visit Ms. Harlow's old home. It turned out to be a very nice evening and the home was beautiful. I kept imagining how many romantic nights Ms. Harlow had enjoyed there. At the end of the evening, Jay Sebring asked me for my phone number which I happily gave him. On the drive home one of the other girls told me that Jay Sebring had dated Sharon Tate and was still madly in love with her.

It didn't take Jay long to call me—and he was handsome. So a couple of nights later I found myself driving up to his home for dinner: Jay did not want to be in noisy restaurant. I found him to be quiet, well mannered, and mysterious. He had a lovely collection of art, books and music, all of which fit splendidly in Ms. Harlow's classic house.

The evening was going fine until he insisted that we go into his bedroom. I declined, but he said, "I just want to show you another of my collections." I didn't want to be rude so I walked

to the doorway of his master suite. He carefully extracted a handsome, hand-tooled leather case from under his humongous bed. He placed the case on the bed and opened it. He said, "Cynthia, I have collected these exotic whips from all over the world!" I quickly excused myself for the ladies' room. While I was in there, all I could think of was how happy I was that I had driven my own car and could leave quickly. Unfortunately, I left a ring there, a gift from a very special friend. I had taken the ring off to wash my hands in the ladies' room and throw some water on my face. But I forgot to put it back on.

The next day I called Jay's house and arranged to pick up my ring the following day.

But that night, Charles Manson and his followers murdered Jay Sebring, Sharon Tate and others. Even though the ring was very precious to me, I never had the heart to call again. A lost ring seemed so minor compared to the tragedy that had just happened.

Cynthia Myers was born on September 12, 1950. Cynthia was raised by her mother and family after her father was killed in a car accident when she was four years old. She was the first ever Playmate born in the 1950s. Her Centerfold and pictures were shot in June 1968 when she was 17 years old, but it was Playboy's policy to wait until a Playmate turned 18 before her pictures would be published. She went on to make a number of movies, and in 1994 her Centerfold went to the moon courtesy of some pranksters at NASA. Cynthia died of lung cancer on November 4, 2011.

Vicki Peters –
Miss April 1972

HOW I BECAME A PLAYMATE

When I was 19, I did a photo-shoot for fashion in Playboy with photographer Douglas Kirkland. When Playboy saw these shots they asked me to test for a Playmate. I shot with Mario Casilli the first time, and was put on hold. Then I shot with Pompeo Posar, but those were put on hold, too. Mario finally shot my Centerfold and it was accepted, two years later. I was the first Playmate to shoot partial nudity before they shot full nudity.

I was chosen Miss April 1972. To celebrate, my high school girlfriend Janice Fuller and I went to a restaurant on the Sunset Strip called Stefanino's. The man who greeted us was Nicky Blair. The now-famous Nicky Blair was working at Stefanino's and the place was one of the hottest restaurants at the time. (The restaurant later became Nick's Fish Market and Nicky Blair's, and then a private club named Trousdale.) Nicky knew everyone, and everyone loved Nicky. He mentioned to us that he was a good friend of Elvis Presley. Elvis was playing in Las Vegas to sellout crowds and if we wanted to attend, Nicky said he could arrange tickets for us. We were thrilled.

The next day I called Nicky to remind him we wanted to go. He told us to call Joe Esposito when we arrived at the hotel; Joe would take care of everything. We hopped on a plane Friday afternoon and flew to Las Vegas for the weekend.

When we arrived at the hotel, we called Joe. He told us to meet him at the bar before the show, and he would take us into the showroom to make sure we got good seats. He bought us a drink and we followed him into the showroom, where we had the front row center table. He told the Captain to take good care of us, too. A bottle of champagne showed up at the table, compliments of Joe Esposito. Little did he know we weren't even old enough to drink.

ELVIS & ME

We watched as the lights dimmed, the gold curtain went up and Elvis exploded onto the stage. I was shocked at how handsome and charismatic he was. He was the most gorgeous

man I had ever seen. The audience went crazy as he sang and gave out his trademark scarves. I sat there just thinking how lucky I was to be there. During the show Janice said to me, "Vicki, he's looking at you."

By the end of the show, everyone was so high, he was truly great!! As we started to leave, I had barely gotten up from my seat when Charlie Hodges, one of Elvis's band members and friends, walked out from behind the curtain and invited us backstage. I had no idea what to expect. He took us to a large dressing room filled with flowers, teddy bears, gifts and several telegrams from famous people hung on the wall congratulating Elvis on his performances. Charlie introduced us to some of the band members, singers, Elvis' father, his stepmother and other family and friends who were there.

Elvis was in another dressing room taking a shower, and everyone was told he would be out shortly. As we waited, I was too nervous to eat anything except a banana. Charlie was laughing and making jokes at me. Casually he said, "My boss wants to meet you." Before I could answer a door opened and in walked Elvis.

He was tall and lean, no longer wearing his famous white jumpsuit; he had changed into a loose black jacket, with black tights and an electric blue scarf hung around his neck. His face was tanned, still a bit shiny from the performance, and his jet black hair hung down over one eye. It was instant chemistry. He was absolutely perfect.

He walked up and, with that famous smile and Southern accent, said, "Hi, how ya doin? Aren't you a pretty thing?" He kissed my hand and continued, "What's your name, darlin'?"

I replied, "Vicki Peters." He said, "I'm Elvis! did you enjoy the show?" I said, "Yes, it was fantastic and you're fantastic."

He said, "Thank you very much. That's a great dress you're wearing."

I was wearing a full-length black jersey dress with a slit up the front and high heels. Standing in my high heels I was eye-to-eye with Elvis. He had the most beautiful eyes that just went right through you. I thought I was going to melt. He leaned over and said, "I have to say hello to some people here. Don't leave, I'll be right back."

I watched as he signed autographs, laughed and joked with everyone. He kept looking at me, smiling and winking. Charlie sat close by talking to me and my girlfriend. After about thirty minutes, Elvis rushed back and said, "Let's get outta here, this place is a drag. Let's go to the other party." With that, he grabbed my hand and whisked me out the door into a private elevator to the top of the hotel.

At the end of a long hallway, we entered Elvis' suite, which was huge. About twenty or so people were hanging out and, of course, Elvis was the center of attention. Like a gentleman he sat next to me holding my hand or resting his hand on my knee; he was so sweet. You could see all of Las Vegas from there, and it was spectacular! Someone started to play one of Elvis' songs on a tapedeck, *Suspicious Minds*. Elvis started to sing and then everyone joined in. He loved joking around and teasing everyone. He had such a warm and friendly quality about him. Everyone named their favorite songs and he'd go into singing a couple of verses of each one. We were all having such a great time, but it was getting late. I was surprised when Elvis told everyone to go down the hall to Joe's room and continue the party. He whispered to me, "I want you to stay here with me."

Joe gave Elvis some pills to sleep and left with my girlfriend to go down to his room. Elvis explained he was still "up" from his performance. He said he would get so "psyched up" from his performance that he needed tranquilizers to come down.

He took my hand, we walked out on the balcony and he kissed me. I couldn't help opening my eyes for a split second, looking at him, and saying to myself, "Oh my God, I'm kissing Elvis Presley!" We stayed there for a while talking, then he took my hand and walked into his bedroom. He closed the door and kissed me again. He took off all his clothes, his body was muscular and firm in all the right places. He carefully removed my dress and pulled me down on the bed. He was a great kisser and an incredible lover. Unbelievably wonderful and open!

After we made love we talked till dawn. He had a kind of boyish quality, I can't explain it, he loved to tell me stories, about everything! He was very spiritual too. He told me a story how he was riding on a bus and God appeared to him from the clouds. He said that God had told him he was put here on earth

to perform, and he belonged to the people. He spoke of it like it was his mission. He talked about his failed marriage and how he loved Lisa Marie. He always glowed when he talked about her; he was so proud to be a father and how it had changed his life. He wanted to be there for her always, and when he was at home he would watch her sleep. He loved his mother and spoke of her death as the worst thing that ever happened to him in his life. He hated Hollywood, and the movies he made. He just loved to sing and perform. He had a whole new life planned to just tour and make music.

The next afternoon we got up at two. That was the time Elvis would get up every day, and we had breakfast in his room. He liked eggs, bacon, hash browns, and everything with lots of pepper poured over the top, with milk. He asked me to spend the rest of the weekend with him, and longer if I could. Of course I spent the rest of the weekend with him. Unfortunately, I did have to go back to LA and start another exciting experience— posing for Playboy!

It was the beginning of a wonderful relationship that lasted a year with trips back and forth to Vegas to be with Elvis. I returned several times with my family and friends. He was a great person, a very special human being. We shared some great times which I will never forget.

Victoria Peters was born on September 9,1950 in Minneapolis, MN. Her Centerfold was shot by Mario Casilli. She graced the pages of Playboy as Miss April 1972. In 1970 she appeared in the film "Blood Mania" along with fellow Playmate Reagan Wilson. In 1980 she married film producer Jeffrey Konvitz and they divorced in 1988. She is now a partner in a very successful Real Estate firm in Southern California.

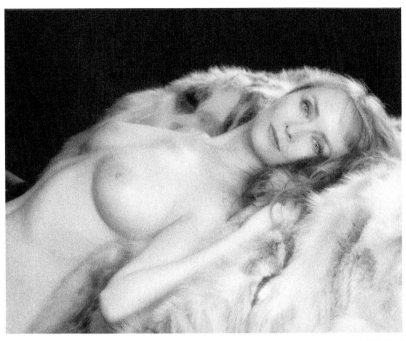

Bonnie Large –
Miss March, 1973

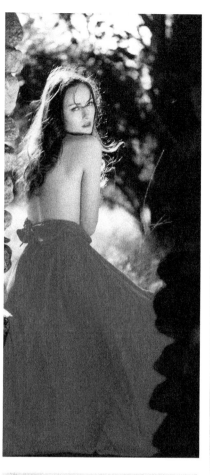
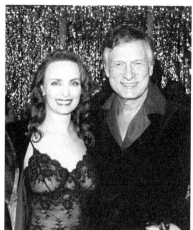

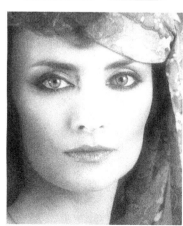

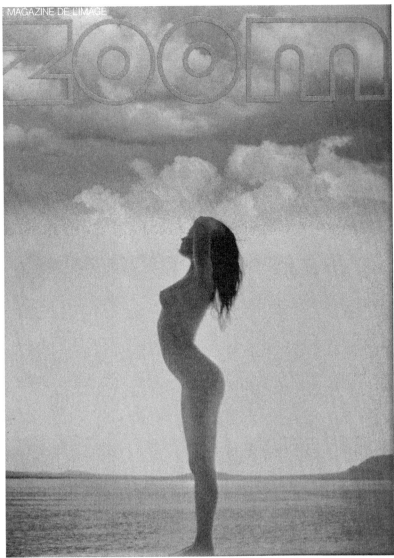

Photo by: Pete Turner

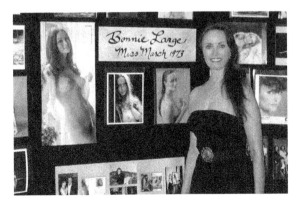

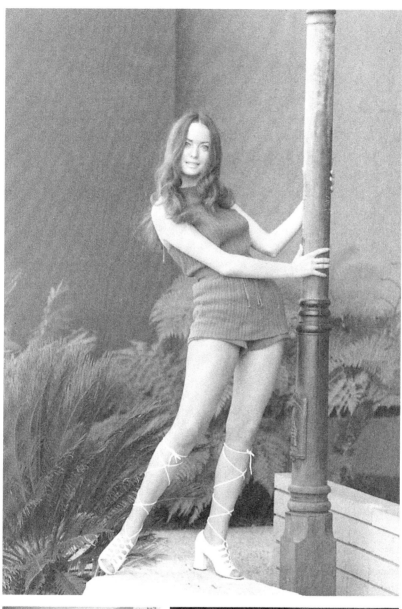

THE MILE HIGH CLUB

An acquaintance named Sid, a producer, called and asked me to have dinner with a friend of his who was only in town for the night. His friend needed a date to take to a special dinner at the Beverly Hilton where he was being honored as a famous. I was reluctant, afraid of what this man would be expecting, but I accepted. A limo arrived to take me to the Beverly Hills Hotel for lunch with Sam Douglas. He wanted to look me over too, not knowing Sid's taste in women. He was delightful—so polite and gentlemanly. I was impressed. The lunch went well. Sam was a Texas guy who just happened to be a self-made millionaire.

Sam brought me home in the limo to pack. I was so embarrassed by my little one-bedroom house. I'm not the best housekeeper; I had thrown clothes everywhere, trying on everything I owned for that evening. The dishes were dirty. He didn't care and we left for the airport and our flight to Mexico.

That night the limo picked me up and then went to get Sam at his private bungalow at The Beverly Hills Hotel. He looked so handsome; I could feel his strength and my attraction to it. His other friends were there. One was a bigwig at Warner Brothers We decided to take the Warner Brothers jet down to Puerto Vallarta.

The whole group on the plane was lively, except me. I felt a little out of place and tried to ease my discomfort by necking with Sam. I swear I was all over him, he must have thought I was a wild woman. Arriving at the airport at dawn, we were driven up to the villas at Las Brisas. The view was incredible, as was our pool and a grassy area overlooking the city. We sunbathed nude. We had wonderful dinners, and made love. We never made it down to the city.

Sam's private jet came from Houston to pick us up. There was a pilot and co-pilot, with the curtain pulled, but they must have been listening to me as I became a member of the Mile High Club. I wasn't quiet about it. I may have been a Centerfold, but I really was the *girl next door*. Sam even had to tell me what the Mile High Club was. I remember peeling off our clothes, laughing and taunting each other. It was so nasty! We were like

animals; we were definitely flying at full throttle. The jet dropped off Sam in Houston for a business meeting and I headed back to LA.

On my next trip to Houston I stayed at Sam's home in Riverview. It was an exclusive area. I had never been to Texas; Sam had a shotgun in his car. What a beautiful house with a great bedroom! We had friends over to dinner and a houseboy who cooked. We went to football parties, discotheques; Sam was great. I wanted to marry that man, but he wasn't ready. He was just ready for the wild thing.

I COULDA BEEN A CONTESSA

The villa was beautiful, but I was angry at Marisa for having me stay there. I was supposed to stay with her in her apartment in Madrid. She said that there was just not enough room for me to be comfortable. Alvero Torcero Viscount was very nice, but I had come to be with Marisa. The green grass extended all around the villa, looking down at a beautiful serene scene with the trees surrounding the pool. It was peaceful, elegant, comfortable. I felt at home.

It was summer, and it was hot. Marisa brought out her friends to visit. Blood tends to run hot when you are lying topless by a gorgeous pool. All of the girls were playing nude in the water, breasts bobbing, splashing and laughing. The men were tanned and strong, showing everything. Incredible meals, dancing and hashish! No hash for me; I wasn't into drugs, however, it's hard not to get caught up in the high of the moment.

The dance of heat and passion came to a head one night with the Viscount, as his body rubbed up against mine and we looked into each other's eyes. Dancing close, my breasts rubbing against his chest, feeling our heated breath on each other's skin, feeling and imagining how he would feel. I remember everyone leaving and we began kissing passionately on the couch, his body on top of mine, making love through our clothes. He gathered me up into his arms and carried me into his bedroom. It was like a scene from the movies. Our clothes fell away, and we revealed ourselves for the first time in a sea of passion. He was hot like

the season; we both were.

For the next five weeks we made love. My place seemed to be in his bedroom. Fabulous dinners, making love, sightseeing, making love, moments of closeness, making love, the gazpacho, the hot afternoon naps. We traveled to the mountain town where the Romans had built aqueducts to carry the water to the city. The streets of Madrid were filled with history. We canceled my trip to Ibiza and stayed together, much to Marisa's disappointment. Never wanting to leave each other, we planned my return. He asked me to marry him, to be the Viscountess. It was a fairy tale. The castle was his villa; the clothes were casual.

When I returned home to the U.S., reality set in. I realized that I could never live in his society. The mistresses went on the town with their men and were given everything. They even had their children with them. The wives stayed home with their children and went to church. It was a Madonna complex, a philosophy I couldn't deal with. I never returned, but he called.

I later learned that much of what he told me was a lie, including the buildings that he had pointed to and said he owned. My decision, I had concluded, was the right one.

I only regret leaving behind my beautiful hats and Gucci scarves in my hat box for when I returned. Some government official's mistress is wearing them now.

GENE SIMMONS AND MICHAEL CRICHTON

My friend Mark called and asked me to go on a blind date with a friend of his. I was not impressed. In fact, I was rather annoyed and offended. After all, we had dated and why wasn't *he* asking me out? I knew who the group Kiss was, but it wasn't my kind of music. Gene Simmons, one of the founders of Kiss, called and he was nice on the phone, so I decided to go. Gene called from the studio where they were rehearsing and he said to wear leather. Luckily, I had bought an all-white leather suit in Ibiza that summer. I had only seen an album cover of the band, my nephew's album, so I did not know what to expect.

Gene was tall, dark and good looking. Thank God he didn't wear his stage makeup. We met at the studio and drove to Spago. He was in all black leather and I was in all white – quite a couple. He was easy to talk to and very conservative. No drinking, no smoking, no drugs. He was a businessman and a junior high school teacher who saw what the kids wanted and gave it to them. When the paparazzi snapped our photos as we were leaving, Gene pulled them aside and asked that they not use those photos, something about Diana Ross or Cher, whomever he was dating in New York.

We ended up at my house and things got out of control. We couldn't stay away from each other. After a night of incredible passion, he flew back to New York and continued to call until he came back out west to plan his role in a movie being filmed in Canada by director Michael Crichton. We had dinner at Michael's house in Brentwood and I listened to all of the plans for the movie. Later, we went back to my place and made love for most of the night. Gene was heated, nasty, lusty, and exciting, but I couldn't feel close to him. I didn't even know about his famous tongue until someone asked me if the rumors were true. Gene obliged me with a demonstration. Then he flew back to New York again. I was invited to use his New York place anytime because Gene was on tour all the time, but Los Angeles was keeping me busy.

Michael Crichton was very attractive and single, and lived in Los Angeles. Michael called me and we arranged dinner together at his place. His cook made a wonderful dinner and we kissed and held each other. It was very romantic, on the couch in front of the fireplace. The music was wonderful, Michael was wonderful. He was brilliant and seemed to appreciate my mind as well.

I don't remember if it was that night when we went into the bedroom for the first time. I like to think that I waited, but Michael had been on my mind for some time. I had to stand on the couch to kiss him because he was so tall at six-foot-eight. No way we could dance but lying down, things were different. Michael was a tender lover with great passion and depth, his eyes looking into my soul. I say make love to because Michael had injured his back, so I had to take the initiative. Holding him

is what I remember most, with him holding me, feeling protected and taken care of by a strong, powerful man.

We were both busy and didn't get to see each other often, and then it came time to make the movie in Canada. Both of my men were there, though I hadn't seen Gene since I had been with Michael, and I couldn't tell Gene about Michael because they were making a film together. I had been hearing about the film all through the planning stages, both from Gene over the phone, and from Michael in person. Then the call came. Michael invited me up to the set. I said to him, "Michael, you know about Gene, but Gene doesn't know about you. He's starring in your movie; don't you think that it would upset him? I can only come up there if I'm coming to see Gene."

I didn't see Gene or Michael after that. Michael called me from the Bahamas from another picture, but we lost touch. I have seen Gene with Shannon at the Playboy Mansion. I've spoken to Michael on the phone. He is married and has a beautiful daughter. He's certainly successful, so successful that he says it's impossible to even meet for a friendly lunch without the paparazzi making something of it. He's a gem.

FAREWELL MY LOVELY, JERRY BRUCKHEIMER

A girl I met on an interview said, "Hey, I am going on another interview for a movie, do you want to come?" "Sure," I said. Next thing I knew I was interviewing with Jerry Bruckheimer for the movie, *Farewell My Lovely.* He said, "Bonnie, do you know what this interview is for?" I said, "No." He said, "It's for whores in a whorehouse; there is nudity involved. I don't think this is something you'd want to do." I agreed and he said that he would find something else for me. He was so caring and protective.

The next time I saw Jerry was on the set. I was a Faye Dunaway-looking character in an agent's office. I sat on the agent's desk, reacting to the scene between Robert Mitchum and the agent. Jerry was very attentive, it was my first movie and Robert Mitchum was so sweet. He rubbed my back between

the takes. He gives a great back rub! It was all so exciting. I was so young. Jerry asked me if I'd like to go out sometime. I said, "Yes."

I remember one casual date at Barney's Beanery, where we laughed and had a great time.

Jerry's house was quiet and peaceful, except for the dog. His German shepherd was the love of his life. The dog would hold me at bay, in his bed, when Jerry was out of the room. Talk about trained dogs! I was terrified of the dog and I knew it was either me or the dog. One of us would have to go, so, goodbye Jerry. It didn't last long, but it was fun. Then he married the other "Bonnie."

The next time I saw Jerry was at a presentation of the new network show, *Summer of 1996*. I went up to him and said, "Jerry, I used to date you twenty years ago." He said, "Lucky me." He was so cute. I introduced myself and let the media have their frenzy. Later, I approached him and said, "Does *Farewell, My Lovely* bring up any memories?" He looked at me smiled and said, "I remember you, Bonnie. How have you been?" I answered, "Well, it looks like you've been doing very well." His answer was interesting, "Not really." Considering the loss of his partner, I guess I understood.

The next time I saw Robert Mitchum was at a costume party in Santa Barbara. He was dressed as an African warrior and his wife was dressed as a chicken. They were hysterical.

Bonnie Large was born on September 9, 1952 in Glendale, California and graced the pages of Playboy as Miss March 1973. Her Centerfold was shot by Bill and Melba Figge.

She was the first Playmate to ever appear clearly full frontal nude.She has written screenplays, poetry and is now a practicing hypnotherapist in the Los Angeles area. She has been a wonderful friend for many years

Carol Vitale –
Miss July 1974

BEING DISCOVERED

My career as a model began when I moved to Florida right after turning 18. I did an Oldsmobile ad, was spokesmodel for the Gulfstream racetrack, and was a finalist in the Miss Florida-World contest. When I wasn't modeling, I tended bar at a hotel lounge across the street from the Playboy Club in Miami. I had never thought about being a Bunny until the Bunnies started coming into my bar after work. I kept looking at them and thinking *Hey, I can do that. They are not as flawless as I figured them to be!* I decided to apply, was immediately accepted by the Bunny Mother, Bev Russell, and enrolled in the training program. I was one of five girls accepted out of twenty-five applicants.

After the first month as a Bunny, I was chosen as one of the Bunnies to be featured in the *VIP* magazine. I would also later appear in several of the *Best Bunnies of the Year* features in Playboy. One night in 1972 I met Alexis Orba at the Playboy Club while he was in Miami searching for a Playboy August cover model. Bunny Mother Russell suggested I put on a bikini. As I exited the dressing room, Alexis exclaimed, "That's her!"

We began shooting the very next morning at five. The shoot took the entire day and when we were finished I was sunburned and plagued with sand fleas. Luckily, I had the next day off to recuperate. But the shoot was a knockout and I appeared on the cover of the August 1972 issue standing in the surf wearing a white bikini and a red, rabbit-shaped life preserver! It didn't take Playboy very long to ask me to be a Centerfold.

NOT ALWAYS SO GLAMOROUS

As you can imagine, I have had some extremely strange and funny experiences, some of which I will never forget.

I was on a Playboy shoot on a secluded beach near Miami dressed only in flowers and shells, which were in my hair. There I was, posing naked and enjoying the warmth of the sun and sound of the sea, when along came a gentlemen having an afternoon stroll. It was probably his first nude-on-the-beach encounter, and what did he do? He said, "Hello, nice weather we are having for the time of the year," and carried on walking without missing a beat. He must have been British. The photographer and I were madly hysterical after that.

Another Playboy shoot in Key Biscayne resulted in our seeing the last act of Swan Lake. I was posing naked when this very large man came walking by. This poor guy must have been so hypnotized at seeing me naked that he missed his footing and I swear it took him sixty seconds to regain his equilibrium. Afterwards, I gave him a 6 for style and an 8 for content!

One time I was driving my Jaguar in southern Florida and was stopped at a light when the gentlemen in the car next to me recognized me. He promptly started to masturbate. My mouth dropped open and I used my car's superior horsepower to make a quick getaway!

Carol Vitale was born November 14, 1946 in Elizabeth, New Jersey. After her Centerfold career, she received a degree in Broadcasting and started the talk show "The Carol Vitale Show" which ran on the USA network for eleven years. Carol started her own line of lingerie. Her success allowed her to donate not only her time, but her money to AIDS research. Despondent over her declining heath from Lupus and Scleroderma, Carol died on July 23, 2008 in her condo in Aventura, Florida from a self-inflicted gunshot wound.

Janet Lupo—
Miss November 1975

All photos used with permission by Janet Lupo

HOW I BECAME A PLAYMATE

Before I became a Playmate, I was a Bunny at The Playboy Club in Great Gorge in 1974. They had asked me over and over to be a Playmate, but I was too shy. Then Pompeo Posar was shooting a pictorial of the *Best Bunnies of 1974*, of which I was one. Pompeo came up to the club when he was shooting and talked me into becoming a Playmate. He was so different from all the rest of the photographers; he seemed very caring and made me feel at home. You could trust him with your life and he was a very sweet man. He really didn't look at me sexually; he treated me like a person. His one eye was in the camera and the other was closed. I felt like he was never looking at me.

When he did my Centerfold I told him he would have do it my way – or no way. He let me do it my way which was, nobody was allowed to come on the set when we were shooting unless they knocked, and there had to be a robe at all times, a full-length robe close to my feet so I could grab it and put it on. I never sat around nude with Pompeo and everyone had to knock to come in whether they were bringing in film or lighting, etc. That's how I wanted it and did it, because otherwise I could have never posed—I was way too shy.

When they asked me in my Centerfold what I wanted to do, I answered that I wanted to get married and have a child. I also wanted to be a flight attendant. I did have a child and I became a flight attendant, so I got two of the three.

BILLY JACK AND DISNEYLAND

I never went to Disneyland when I was young. So when I became a Play-Mate, Billy Jack (Tom Laughlin was his real name) and his wife got in touch with me and wanted me for a lead in one of his movies. Back then, they were using people who were not in the union and paying them very cheap money. They wanted me to be a CIA agent murderess. So Billy Jack Enterprises called me out to LA.

I was doing promotions for Playboy so I had to change my

ticket to go to LA instead of Newark. Playboy found out and asked me why (back then they always wanted to know what their Playmates were doing). Why was I going to LA, and what was I doing there? I told them why: I had been cast in a Billy Jack movie, though I had no intention of being in this movie, in my mind. In my mind it was my aim to go to Disneyland and see Snow White and the Seven Dwarfs. I just wanted to see it, even though I was 25 going on 10. I figured, how else was I going to get to California? My Centerfold was shot in Chicago. So this was my chance to go to Disneyland. The Playboy Mansion got word of it and sent for me that night. I went over to the new Playboy Mansion and Mary O'Connor, Hef's private secretary, told me that she did not like (well, all of Hollywood did not like) that Tom Laughlin was hiring people such as me, with no union background, to be in his movies. They hoped I would not fulfill his dream to be in his movie. I laughed and said, "Don't worry, I had I no intention of being in his movie, I only came out here to go to Disneyland." And I did, I made sure before I went out to LA. I asked him on the phone. He asked if there was anything I wanted to do, sightseeing, etc. and I said Disneyland. He arranged it and I went with his six-year-old daughter – we went all over Disneyland. I got my Snow White and the Seven Dwarfs figurines – I was in my glory!

Hollywood soon got rid of him. But I did get to go to Disneyland!

CENTERFOLD FLIGHT ATTENDANT

I became a flight attendant in 1979 for Air Florida. The truth is, I lost my job as a flight attendant because I was a Centerfold. I never told them I was a Centerfold, but one of the captains saw my name on the checklist and turned around to look and confirm who I was with the rest of the flight attendants. The next thing I know, I was treated so badly I couldn't believe what they did to me. It was horrible. The senior flight attendant came to work on one of my shifts and she had a *Playboy* magazine. She had bought one and put her face on the cover. Picture her face on the cover as we were all sitting around waiting for our flight

to come in to go. She says, "Oh, Janet! Look what I did!" And she held it up for all to see, and that's how I found out they knew I was a Centerfold.

I looked at the Playboy and all these things go off in my head. Back then they really did fire you for being a Centerfold. They tried their best to get me fired. They kept setting me up. The senior flight attendant instructed another attendant to lie and say that she saw me ask a passenger to close and secure the back door of the plane. I called the woman and asked her why she lied. She said, "Because they threatened me that if I didn't lie, they would fire me. I have two kids and I need my job." Then she just started to cry. I was so upset, but there was nothing I could do.

There was one time that the manager held me back from going with the rest of the flight attendants to the plane. She said, "I am going to do your evaluation." (The usual procedure is usually to set one of your days off for the evaluation.) I said, "Right now? I am going on my flight, I have to leave, the plane is going to leave." Passengers were boarding, and attendants are supposed to be on the plane long before the passengers board. She said, "Oh, don't worry! We'll be finished before the plane takes off. You can go down late, it's no problem." So I did the evaluation and ran down to the plane before my flight took off.

A month later the shit hit the fan. Someone said that I asked a passenger to close the back door of the plane and that I didn't show up to the plane on time.

We went from forty flight attendants to four hundred in three months. It was amazing! Air Florida turned similar to PeopleExpress. But it came down as soon as it went up. They went out of business. So as I lost my job, they all lost theirs. I had a lawyer and everything afterwards but when they went out of business I just dumped the whole thing. You just sit back and God will always take care of you. Remember that!

Janet Lupo graced the pages of Playboy in November 1975. She is a real estate agent.

Janet has recently has been in New York magazine, Inside Edition, Entertainment Tonight plus many other publications. Janet is the creator of "FOUNTAIN OF YOUTH" .body oil. It has been called the "Magic Potion of Youth," and it can be purchased at www.foybodyoil. com.

Pamela Bryant –
Miss April 1978

MY POEM

The Playboy mansion is like a show
Where all the Hollywood people go
Hugh Hefner is a charming man
And he will lay you if he can

He likes his Playmates
Miss June and July
I was Miss April
But how fast my month went by!

I lived at his house
A month or two
Met a lot of producers
Most were bad news

They offered me parts
In pictures they said
If I'd take off my clothes
And go to bed.

So I wondered why
I didn't get many parts
I guess I was too much
Of a sweetheart

The crazy parties soon got to me
And if you don't put out
You must get out
So soon my day came to leave

So I worked hard
In Hollywood town
And didn't let the bullshit
Get me down

I got those parts
In the picture shows
I may be a star someday
Who knows?

And what I have to say
To those who read
Is try, try, try

And if you want to be
A Playboy playmate
Just make sure
Your tits look great

Send your photos in
In care of Playboy
You can be sure a playmate
Is a man's best toy!

ARRIVING AT THE MANSION

It was our fourth day on the road from Palm Beach, Florida en route to Los Angeles and the Playboy mansion. I had cried the first day all the way up the Florida turnpike because I was leaving absolutely everyone and everything I had ever known for a destination with my fate unknown. I was scared out of my mind! I was barely 18 years old, and had just left my fiancé and Indiana University.

By the time my Centerfold was shot and had been accepted by Hef to be published as Miss April 1978, his secretary Mary O'Connor had called via Tom Staebler, the art director for Playboy, and invited me to come to Los Angeles and live at the Mansion. I had been living with a college boyfriend who I had left Indiana University with and we had been living the summer of 1977 in Palm Beach, Florida. My boyfriend had wanted me to decline the Playboy offer and go back to Indiana with him and get married. But I was sure my destiny lay was far beyond my hometown. I packed my car with everything I owned and headed

for the Mansion.

I was driving through the West Texas desert when I fell asleep at the wheel and flipped my car, totaling it! I remember crawling out through the window on the driver's side and saying, "It looks like I'm taking a bus to LA." I was rushed to the hospital and received fourteen stitches in my head and, luckily, a friend of mine bought me a plane ticket from El Paso to Los Angeles. The next day I arrived at LAX where a Playboy limousine picked me up at the airport.

The night I arrived at the Mansion, the movie *Star Wars* was premiering and Hef, accompanied by his girlfriend, Sandra Theodore (Miss July 1977), were going, as well as Patty McGuire (Miss November 1976) and her date, James Caan, who was living at the Mansion. There was also a big party being thrown for *OUI* magazine.

The butler showed me to my room and told me to get dressed for the party and come down. By the end of the evening I was smoking a joint with Hef, Sandra Theodore, Patti McGuire and James Caan. I thought I had died and gone to heaven. And nobody, including myself, cared about my black-and-blue body with fourteen stitches in my head.

The next night about six Playmates and Hef went to a party in the limo, and after the party we went back to the Mansion and got in the Jacuzzi. There were all the girls and just Hef, going from one to other with a bottle of baby oil. I swam out the tunnel and went and hid in my room.

The next morning Hef came into my room unannounced – he had a key to unlock the door – and said, "Couldn't you feel the vibrations bouncing off the walls last night?" He was referring to smoking a joint in Jimmy Caan's room the night before. He went on to say he knew I didn't want to be in the Jacuzzi that night, and then he proceeded to rip the sheet off me and planted himself between my legs and started doing the "wild thing." Just as he was really getting going, the bedroom door opened and it was the butler with Patti McGuire's breakfast. I screamed and started saying, "I'm sorry! I'm sorry! I just can't do this!" Hef got up and left.

The next day Hef found me alone in the Jacuzzi. "Can I join you?" he asked. I must have given him a look of sheer terror

because then he said, "I'm not going to hurt you. I promise, all I want to do is talk to you." Then he ever so bluntly asked me, "Pamela, did you think you were going to come to my house and not sleep with me?"

I tried to explain to him that I had thought it might come up, but as he had a girlfriend, I wasn't sure the problem would occur. He tried to convince me that there was a lot of good, loving sex inside the walls at the Playboy mansion, how they were all one big, loving family that looked after each other and how he wanted me to be part of the family. Hef went on telling how Sandra had been a Sunday school teacher, and basically that joining the orgies in his bedroom every night was as normal as having tea. After that talk, Hef began calling me every night and asking me to come to his room. I would always make up some excuse about having something else to do. It was not long before Hef's secretary called me and asked if I had found another place to live!

OJ SIMPSON

It was Christmastime, 1984, and three days before I actually met OJ, I had a very vivid dream of having a wild night of sex with him. That morning I awoke with a big smile on my face and my boyfriend, Chris Mancini, asked me what I was thinking about. I told him and he teased me, "I know what your fantasy is!" But actually it hadn't been. I had never met OJ and had never thought about him. But it was a strange dream. So real!

Three days later it was Christmas Eve and I met OJ at the Bistro Garden. He was having lunch with one my girlfriends. They laughed and said later that he had come leaping over tables to meet me, like in his Hertz commercial. He sat down next to me and started buying drinks and laying on the charm. He ended up asking me if I wanted to complete my Christmas shopping with him and he would give me a ride home. Sure, I thought, all the while thinking how strange it was after my dream of a few days ago. We walked over to the famous Rodeo Drive and went into Georgio's. More drinks, and OJ had the bartender "marry" us. OJ was getting pretty drunk, so we started walking, but he

wasn't drunk enough to buy me this beautiful pair of boots I wanted. After hanging out in a few shops and getting what we needed he drove me to Sunset Plaza in his white Rolls Royce. I tried to kiss him goodbye in the car; I was supposed to have dinner with my boyfriend and his parents, Henry and Jenny, that night. I had no intention of inviting OJ in. But he said he needed to use the bathroom. After he used the bathroom, he came into my living room and I told him it was so strange he was here because I had had a dream about him a few nights before. He asked me what the dream was about. Not wanting to answer, I excused myself to ladies' room.

When I came out, OJ was naked in my room on my bed with pillows down his body hiding his enormous hard-on. He had that million-dollar smile, and yes, we all know what happened next. We did have sex on Christmas Eve and very well, I might add. In fact, it was too much. He didn't stop. It went on and on and on! On the bed. On the living room floor. In the kitchen. It was all too much and finally I just wanted him to get off me. Enough is enough! Finally he left and went home.

I heard he had dinner with Nicole that night. It was the year before they were married.

WARREN BEATTY

Warren Beatty was always trying to seduce me at the Mansion.

I would always brush him off and tell him I something else to do. He always laughed and asked me if we could have dinner later on in the week. It was fun flirting, but I never expected or wanted to sleep with him. But then, one evening while I was living there he came into the steaming Jacuzzi cave on the property with two Playmates. He saw me alone in the water and sent the other girls away with a wave of his hand, dropped his robe and slid into the Jacuzzi.

He was a breathtaking sight, and in an instant I had decided what to do. I was unable to resist his gorgeous flesh! Life was changing very fast for me in those days. And I don't regret what I did. It was fun, but I bet not nearly as much fun as he had after

me with his two bisexual Playmates of the Year who were using him as their fantasy!

It was years later that I found out from the other girls that Warren and Hef had a bet on how many girls they could have sex with in one day.

Pamela Jean Bryant was born on February 8, 1959 in Indianapolis, Indiana. She first appeared in Playboy in the September 1977 pictorial "Girls of the Big Ten." She went on to have a very successful acting career in both the movies and television. She appeared in such movies at H.O.T.S. (1979), Private Lessons (1981), and Looker (1981), and by the time she was 25 had appeared in over eighty-six television shows including Magnum, Fantasy Island, Dukes of Hazzard, and The Love Boat. She obtained a degree from U.C.L.A. in Fine Arts. She started her own redecorating business. Pamela died on December 4, 2011 in Hawaii of an asthma attack.

Photo by: Michael Dunn 1977

Liz Glazowski –
Miss April 1980

Photo by: Michael Dunn 1977

Photo by: Michael Dunn 1977

BECOMING A PLAYMATE

I went for an audition in 1978 for the 25th anniversary Playmate at the Playboy Mansion on State Street in Chicago. It turned out I was one of the top ten finalists out of thousands of girls. Candy Loving won that title, but they knew that they wanted me as a Playmate. When, I did not know. I did test shoots with Pompeo Posar, Richard Fegley, and Arny Freytag in Chicago and then went to LA.

It happened very quickly when I got to LA: I shot with Ken Marcus. All of the pictures were finished after about three months and then I waited for the verdict. Was I in or not?

Hef told me he was sorry, but I did not have the personality for a Playmate. So I was rejected, but he invited me to stay there for the rest of the month, so that was that. So, I was like what the fuck, I had spent all this time doing all these pictures and I didn't gain anything at all. I didn't receive any money until I was accepted as a Playmate, and then they started giving me a draw. It was coming down to the wire and I'm thinking, *Well, shit, you're here. All the pictures are done, the whole Centerfold was done and it was the same fucking Centerfold. He just said I didn't have the personality?* So I wrote him a note and put it in the sculpture at the top of the staircase. I was offering myself to Hef, offering to party with him, hoping that it would sway his decision to let me become a Playmate. What else was I going to do? If he wanted to party with me, that was my proposal. I spent all this time on photo shoots, moved, I gave up my job. It's time to make a decision. So, I took a Quaalude and had a glass of champagne and was able to party with him. Then, within two days Hef comes in and says, "Congratulations! Did you know you've been accepted to be a Playmate?" I thought, uh-huh, so that's what it took. No regrets!

OOPS

I was scheduled for an outdoor nighttime photo shoot in Chicago at a disco club that was popular back in the late ,70s

and early ,80s. It was summer, so I was wearing this beautiful sleeveless red, silky, skimpy wrap dress and a colorful sequined hat. I was standing next to a limo outside the club waiting for Ken Marcus to set up the shoot, and in a short period of time a crowd of people started gathering around. I was looking around at the crowd as I waited, and I spotted a famous Chicago photographer named Stan Malinowski. I overheard people in the crowd saying "Oh, you know he's here, the famous photographer." He actually rode in on a bicycle.

When the shoot was over I was walking away from the car and the bottom of my dress got caught in the door. I ended up flashing the crowd as I didn't have anything on underneath. The crowd went "Woo!" and then was silent. I felt everyone staring at me; I could not believe it. After the door opened and my dress was released, I walked away as if nothing happened. I reminded myself that this was a photo shoot for Playboy and it was not unusual that I was not wearing anything underneath my clothes. But the crowd got a preview of my upcoming pictorial. This particular picture was published in my issue (April 1980), on the bottom of the first page.

You never know what to expect at a photo shoot. In this instance, the crowd got a free look. I still laugh to myself every time I think about this moment in my life.

KEN MARCUS

For a portion of my Centerfold pictorial, Ken Marcus came to Chicago to shoot me at a beautiful condo in Old Town. The first shot was to be taken in this shower that had a tropical theme: it was designed like a rainforest, huge, and I felt like I was in the Amazonian rainforest. It was one of my first shoots with Ken so I was a little nervous.

To calm my nerves, he suggested we smoke some weed. I didn't really smoke weed in those days, so I got pretty high. So we were shooting these photos and I was so stoned my eyelids were heavy and I couldn't pose that well. I didn't feel sexy, I just felt stoned and dopey. When we viewed the pictures, while we were there, I couldn't help but laugh

at how stoned I looked. Ken and I burst into laughter at how out of it I looked. Of course, those pictures were not published.

I loved shooting with Ken; everybody I knew of liked working with him. Ken was always so much fun to work with and his photography was always flawless. He made us look like a dream come true, every man's fantasy of the "girl next door."

Photo by: Munoz photography, styled by Glen Marlo, 2015

Liz Glazowski was born on December 19, 1957 in Zakopane, Poland but grew up mostly in Chicago. Liz has a degree in business management and now lives in southern Florida.

All photos used with permission by Liz Glazowski

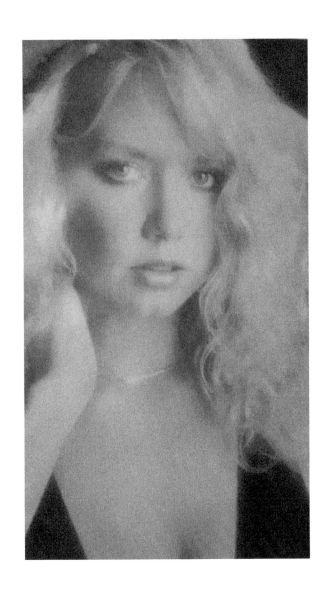

Kym Malin –
Miss May 1982

All photos used with permission by Kym Malin

HOW IT STARTED

Playboy called me after they saw the pictures of me winning "The Most Perfect Body in Texas" contest. I was wearing a bikini. They flew me to Chicago for a test shooting. I was only 19 years old. Pompeo Posar was my photographer. I met Janice Moses and she said, "Okay, you're going to be a Centerfold in six months." I thought it was just a test shoot. But no, it was decided that Pompeo's photograph was going to be my Centerfold.

It was! Life was great.

Being from Texas, I grew up in a very corporate and Republican family, and I was a free spirit. My family told me that if I didn't finish college or join the military I was going to end up being a loser in life. Were they wrong! Coming from that background and not following the views of my family... Life was great for me.

I got to ride in a limousine, I got to stay at The Drake Hotel in Chicago, and "applause" I just loved it.

I loved Playboy magazine prior to that; I started looking at the magazine in 1977. The model Debra Jo Fondren was my idol because she was from Texas and she had that long blonde hair and was so gorgeous. I also admired Candy Loving who was the 25th anniversary Playmate, she was so hot!. I emulated these girls when I was in 11th and 12th grades.

When they flew me to Chicago, I was given an expense account and could order anything I wanted. I felt like I had made it. For me it was awesome!

I went to Chicago and then back to Dallas, then to LA where I did my head shots. When I arrived in LA there was a limousine waiting pick me up. I had never been to LA, and driving down Sunset Boulevard I drank champagne, because I'm that type of girl and I brought it to celebrate. I could smell the flowers; it was so gorgeous – to die for!

I told the limo driver, "This is where I am going to be living. This is my kind of place," and sure enough, I did not leave for a very long time.

THE PLAYBOY MANSION

I started seeing the Playboy Mansion West, and then the driver pulls up and says, "I have Kym Malin," as we just pulled up that driveway. Looking up at the house, I was like, "I've made it!! I don't know what I did in life but I have made it to the top, I'm a *ten*, I'm somebody." I arrived at the entrance at the top of the hill and the butlers showed me my guesthouse room. I never stayed in the main house, and I'm glad.

As I went to the guest house I was thinking, *This is my kind of scene, man. The champagne and wine and everybody's so nice, and my family told me I'd never amount to anything.* It had been kind of depressing being made to feel like a loser.

I got to the Playboy Mansion and I knew there was a great world out there waiting for me. *This is my kind of place and I loved it and it loved me.* So at first I thought, "I have to ,fit in' and with my bubbly personality, I was born to this." My job would be to do promotions for car shows and sign pictures all over the U.S. When I was done, I would always fly back to my room, *my place at the mansion.*

Quite often there were only two twin beds in each guestroom in the guest house, and when I would get back there would sometimes be a new girl, a brand new Playmate, in my bed and I would be like "that's my bed, actually." That is how I met Kim Evenson. She was in *my* bed. I kind of took possession of it. I had pictures of boys thumbtacked up behind my bed. It was like, "Can't you see my guys are behind my bed?"

I traveled all over the United States, to every bloody car show. I was gone every weekend and would always return to the Playboy Mansion. I had people asking for my address. I would tell them it is 10236 Charing Cross Rd., Holmby Hills, CA.

Eventually, I got call from Mary O'Connor's office, who had been Hef's personal secretary since the beginning of Playboy. She said, "Kym, you can't use this address for your personal business or your things." I said, "Why not? I live here, where else am I going to have it sent?" Mary said, you can't do that for tax purposes. I was like, "Oh well, whatever..." I never changed my ways, but I did change my address.

While I was there, it was Mary O'Connor who allowed me to stay as long as I did and perhaps why I didn't move into the main house bedrooms. I felt safe out in my little guest house, out by the tennis courts. It did get lonely eventually: I was a 20-year-old girl, beef-bred, and I liked boys. There were no boys on the property of the Playboy Mansion except my "baby butlers." The majority were from UCLA and USC, and God bless them. You're not allowed to bring boyfriends or guys to the Mansion, so the only guys on the property were Hef, old-men friends of Hef's, and celebrities.

One thing I learned early on is that you don't want to date or be with actors because in the morning you gotta fight them for time in front of the mirror in the bathroom. They were pretty boys. They always took more time getting prettier than me.

My mother had gone through a divorce when I was 16, and I had to keep out of the house. I wouldn't obey the rules and people were telling her to exercise tough love. Mary O'Connor, whom I had a great relationship with, became like a mother to me at the Mansion. She told me the unwritten and unspoken rules of the Mansion. She told me, "Kym, you seem to get along very well with the girls." The new girls would arrive and as you know, the pool is to die for, especially the Jacuzzi, the Grotto. So in the summer, Hef's guests would arrive around seven-thirty for movie nights on Friday and Sunday nights. I was still getting sun out by the pool; these girls were all very young and barely legal from Idaho, Kansas, wherever in the Midwest. They would come back from shooting at the studio, take off their makeup and go sit by the pool. So when Hef's guests came up, I was to get the girls to come up and say hello to his guests. So it was an unspoken rule that I took the role of being a cheerleader for these girls to come out and welcome guests. I would say, "Hey, there are celebrities and Hef, and whatever movie just came out at the box office, let's get dressed up and go say Hi to these people." That's what paid 100 percent of my rent. As long as Hef saw me on movie nights dressed up, I could go to sleep afterwards. As long as I walked through that door with girls and said, "Hey, how are you doing? Oh, thank you," my rent was paid.

TOM CRUISE

I met Tom Cruise, mister "Risky Business" himself, on "movie night" at the Mansion. Tom was actually my age but my radar was going, *You're young.* I asked him if he had ever had a tour of the grounds here at the house. He said, "No." He said he had heard there were monkeys and animals. I said we have one of the largest Redwood tree forests here in LA and asked him if he would like a tour. I took him out to the monkey cages and the winding tour of the animals. We walked into the forest where there is a wooden bench we shared. We did not kiss, but we did decide to leave the property, and then went out several times over a few month period. I was not used to having a young buck and acrobatic sex; he would literally hold me up.

I decided not to go out with him anymore because I did not like how he addressed the butlers at the Mansion or the waitstaff at restaurants. I'm sorry, that is just not cool with me. We went to a very fancy restaurant in Santa Monica where he ordered a very expensive bottle of champagne. Now granted, he was just 26, the same age as I was at the time. He smelled the champagne, tasted it and he didn't like it and sent it back. They brought another one and he didn't like that one, either. I said, "Well, can I taste it to see what it tastes like so I can know in the future?" He said, "No." I did not like being dismissed, especially when I wanted to learn. He was just not nice to the staff, so that was that.

ROBIN WILLIAMS

I met a lot of celebrities on Hef's movie nights, but I can say that I can leave this planet knowing that it was at one of them that I met and encountered a true genius. I was making my rounds, playing hostess and greeting Hef's guest. I had ordered champagne and it didn't come out; and a butler ordered it again and it still didn't arrive. So, I went into the pantry to find out what's going on. *Where's my champagne?* I swung open the door and there were all the butlers in a semi-circle and Robin Williams in the middle.

"Oh, here you are," one of the butlers said. "Kym, this is Robin Williams." I looked to the right and my jaw dropped. He started doing all these things, the butlers were breaking out laughing. He had already been entertaining them. I stood there star-struck; my jaw was open the whole time.

I offered to give him a tour of the property and he accepted. I took him to the monkey cage, the Redwood forest, the little wooden bench. We then made our way to the pool and the bath house. I was sure he had been there before, but I gave him the tour. Hours later we ended up back in the game house and stayed in one of the little rooms, and did what probably a lot of people do in there. We had sex, and he was a very sweet guy, and giving. Very hairy, too. I've never met anyone so hairy. I was on top of him and I was two inches off of him because of all his hair. Well, for this world he was too much; he gave, gave and gave; now he's in heaven. I loved him!

JOHN BELUSHI

Mary asked me to talk to Bob Woodward, who was one of *The Washington Post* reporters who broke the Watergate case. He was working on a biography about actor and comedian John Belushi. I said yes I would speak to him about his book, "Wired, the Short Life and Fast Times" of John Belushi. (I am in the index of the book above Penny Marshall.)

I had a phone call one night and they told me that John Belushi was on the Mansion property and that he wanted to meet me.

In the late 70's I watched *Saturday Night Live,* and I was impressed to be meeting one of its biggest stars. I was like, *No way!* I had to put on makeup and doll myself up before I went up to the house to meet John Belushi. By the time I got there they were already in the Jacuzzi, Grotto. So I went to meet him, but there were two guys in the Grotto by themselves, John and Christopher Walken, who I did not know at the time. I walked in, all dolled up, and they asked me if I wanted some blow. I took two hits out of those little spoons, one in each nostril.

Later, John came back to my guest room and tried to teach

me how to "slam dance." It was kind of fun, but very physical.

We stayed up and did a little bit of blow, but we did not have sex.

There had been another night I went out with him to the VIP club "On The Rocks" on Sunset Boulevard. John kept saying, "Come on stage with me and sing *Louie, Louie.* We had already done blow and I'm like *Are you crazy?* He was nice crazy. That happened right before he died. That's why Bob Woodward interviewed me. He wanted to hear about Belushi's partying.

MANSION AND HEF

I really enjoyed living at the Mansion, and then there was one day when I walked into the kitchen because I was friends with the Chef, and I liked the staff. The old cronies scared me but I was smart enough to stay out of the line of fire. These stupid girls came in after the movie night is finished. I am a nightowl so I would be playing Frisbee with the butlers in the great hall and the formal dining room, with the Picasso and other valuable paintings. I was playing Frisbee with Leland, a butler, and it was about four in the morning. Playmates were always told not to fraternize with the butlers, and here came Hef down the main staircase in his white robe. I was standing over by the fireplace and I saw Hef and I just froze; and the Frisbee hit, just close to the Picasso. I was just hoping Leland was not going to be fired. But, thankfully, Hef did not see Leland or the Frisbee.

I was trying to stay out of the line of fire, always, especially during that witching hour when you know damn well they are on the hunt. It was like after the movie and after the drinks you know damn well you better get out of sight, or otherwise you will be what I called "in the line of fire."

I was very lucky that Shannon Tweed was the Queen of the house at the time. She didn't bother me very much and I stayed out of the way as much as possible.

One night, when it was past four and everybody had left, I was in the TV room in the game house, with all the cushions and cushioned floor. I had fallen asleep; I don't usually fall asleep until very late. But it was the first – and only – time I was

propositioned by Hef. I had been there about two years, and I had found out what the word "party" meant. I was a party girl from Texas. But at the Playboy Mansion, "party" had a whole different meaning. It does not mean *Have a good time and have some drinks*. They have something else in mind. It involves threesomes and more.

So, all of a sudden Hef stuck his head in the door and said to me, "Oh, there you are! We've been looking all over for you." I practically had a cow! I was in shock because I didn't get out of the way of this one because he was right there. It was just him – not him *and* Shannon. The first thing that went through my head was, *Well, that's pretty stupid because you have security and they know everything and where everyone is.* "We've been looking all over for you." I knew I was in trouble. Then he said, "Well, Shannon and I wanted to know if you wanted to come party with us." I am so proud of myself that I was able to have enough composure to keep my mouth shut for as long as I could while I thought of what to say.

My response, "Oh, thank you, thank you very much! I don't think I am ready for that right now, but when I am you guys are definitely the ones I want to party with. I just don't think I'm ready right now." He put his hands in the air by his shoulders and said, "Oh, that's all right." He turned and left. I swear on my life that I was so happy for that outcome. They never bothered me again. I was lucky for that, I got away unscathed for a long time.

RAY MANZELLA

The first guy I was sort of in love with was Ray Manzella. He used to come up to the Mansion a lot. After me he was with Sondra Theodore and then Jenny McCarthy. The only time I have ever been dumped in my whole life was by Ray and he dumped me for Sondra Theodore. I still wear the diamond necklace he gave me on my 21st birthday. Ray and I had been inseparable. I moved out of the Mansion and moved in with him in Marina Del Rey. We went to Europe for a couple of months, to Paris, Rome; we were in Lake Como before George Clooney

got there. When we were in Innsbruck, Austria, Ray dumped me. I wanted to go back to Texas and go to college and become an exchange student. I had talked to all these students in Europe who loved traveling, and I said, *this is what I want to do.* Things weren't going that great with Ray and me. I did not want to go back to LA; I didn't want to go back to the Mansion, and I was still in love with Ray. I didn't talk to Ray for a couple of weeks, and when we finally spoke again, he said, "Kym, if I want to fuck Sondra Theodore's brains out, that's my choice." I was like, "What?" I moved back to LA, got an apartment in Venice Beach, and it was awesome, truly awesome.

Kym Malin graced the pages of Playboy in May 1982, She was a stunt woman for the John Hughes film, "Weird Science", a racecar driver on the Playboy endurance circuit. She was in the films "Die Hard" and "Road House."

She was also in many Andy Sidaris films, as well as owning her own talent agency on Sunset Boulevard.

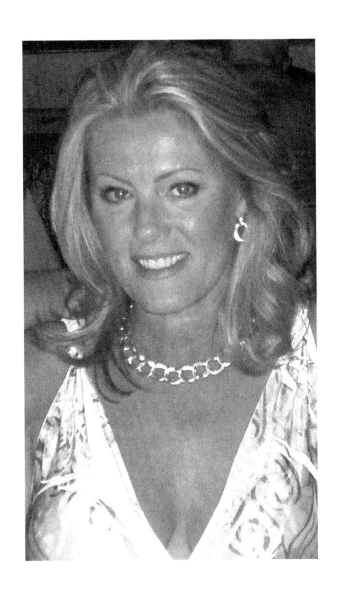

Marlene Janssen –
Miss November 1982

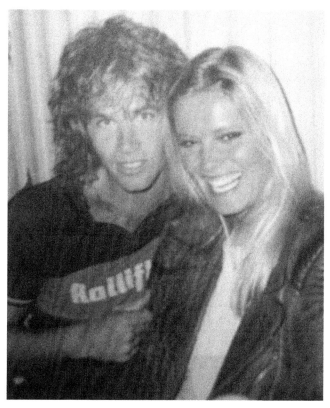

All photos used with permission by Marlene Janssen

THE FANTASY

As a child, I would sneak into the bedroom of my brother, who was ten years older than me. I would find various magazines, and one of them was *Playboy*. I thought, *Geez, these girls are out of this world.* They were so beautiful. I just couldn't believe how they were portrayed like statues. I fantasized about being one of those girls.

THE BEGINNING OF THE FANSTASY

In 1978, my girlfriend from Illinois, Grace, and I just went to California. Actually, we went out for a vacation and unfortunately ran out of money. We decided to stay and get jobs. I worked for a couple of different companies: one was a retail discount chain, similar to Walmart. I worked in their corporate office and one of the girls who worked in the advertising department, Susan, became a good friend. We became roommates. She left the company and took a job as a secretary at Playboy Studio West. I was fascinated that she was working there and seeing all the Playmates or girls interviewing to become Playmates. I couldn't believe Susan got a job there!

I was invited to Susan's wedding and the reception was at Arny Freytag's house. I remember walking around his house in the San Fernando Valley and seeing all these life-sized Centerfold's pictures on his walls. It was his art displayed all over his house. I remember when I was introduced to him; I remember the exact dress I was wearing. It was a tight knit, hot pink, mid-calf dress that showed off my figure and my not-so-large breasts. He started following me around the house; I was so fricking nervous I couldn't believe it. We started talking and he said he would like to test-shoot me. I responded, "I have no boobs." He said, "But you have a great ass." I was okay with that, and still to this day it's my best feature. My long blonde hair probably didn't hurt either.

MY TESTS AND JOURNEY INTO CENTERFOLD HISTORY

I tested in Loraine Michael's sets with the see-through yellow rain jacket and the rain drops. I remember Arny saying, "I really think you're going to make it." I thought, *heck, if these test pictures are approved by Hef, I'm going to have to ask my Mom and Dad.* I needed their approval. So, nervously I called my parents and I told them what I was up to and my Dad said, "Just please, don't touch yourself." My Mom said that if she had the opportunity she would take it. It was very surprising to me because they were German immigrants and from what I considered a very conservative background.

When I was accepted, I was so incredibly shocked. In comparison to other Playmates, my breasts were quite small. But they were cute and small and there weren't so many of us, so they had to throw in a few of us, small-breasted, every now and then.

It was a long and arduous process because I had actually shot four Centerfolds before being accepted. I had been getting a little bit aggravated. From beginning to end it had taken two years. By the time I was a Centerfold I was 24, which seemed old in comparison to the other Centerfolds.

The different photographers who shot me were Arny and Kerry Morrison, who did all my photography other than my Centerfold. I did the traditional pose of lying on the bearskin rug in front of the fireplace. I still have copies of those photos. Another photo session was set at "Le Dome" restaurant on Sunset Boulevard. I was shot walking in the door of the restaurant and, in those days before digital photography, we had to hold our breath and not move. So, I faced the door, turning my head back, arching my back to get my butt up nice and perky in high heels, twisting my head so as not to have a crease in my neck. By the time I finished shooting my Centerfold, I turned my head around and passed out. I had apparently cut off some of the blood flow to my head.

While prepping for Playboy I did not live at the Mansion; I lived in Manhattan Beach and worked at a lot of different

jobs in order to keep myself in survival mode financially until my Centerfold got approved. You don't get paid until your Centerfold is approved. So, four Centerfolds, two years and ten thousand dollars... that really doesn't add up to much.

My third Centerfold shot was kind of crazy. Cathy St. George was my makeup artist for this one and I was kind of walking out onto a porch designed to be somewhat Jamaican style. I wore a sport coat and a hat and had G string tan lines. It was really bizarre. It was a pretty cool concept and we got some gorgeous shots that didn't make it. I was getting quite frustrated.

My last Centerfold shoot, which is my Centerfold November 1982, was taken at the Playboy Mansion on the back porch. I had to be up at three-thirty in the morning with full makeup and hair. We shot at sunrise. All the lighting was pretty much natural. I felt like the Medieval meeting modern-day Wonder Woman.

My boots were taped to the ground so I could keep the stance I was posed in. The wide sleeves on my blouse were taped to the doorway so they would look like they were naturally puffed. I loved everything about it; I thought this Centerfold turned out just fantastic.

HEF LIKED ME JUST AS I WAS

One day after the shoot that was to become my Centerfold, I went out to the pool. I was hanging out there and Hef came out. "Hef, you've got to let me know. Am I going to make it as a Playmate with my breasts not being that large?" (It had already been suggested to me that I get breast augmentation.) "I would like to be taken the way I am, I don't want to be false at this point. This is who I am and I want to prevail and to succeed this way if possible." Hef actually told me, "I love the way you are; we are just trying to find the right shot for you." So I stayed two more days at the mansion, up at sunrise shooting until the sun was too high for the natural lighting.

About two weeks later I found out I was Miss November 1982. I was so excited! And then it gets better: all the follow-up pictures were done in my hometown, which made me ecstatic.

I became the new celebrity in my hometown in Illinois. I still think I am the only Playmate who came from there, and I hope to be the only one ever. I'm proud to be among the group of girls that didn't need a breast augmentation to be in the magazine. They took me the way I am. I always thought, you found me like this, you take me like this!!

PROMOTIONS, MICHELOB LIGHT AND RACING!

After becoming a Playmate, you do all kinds of promotions, car shows, and trade shows where you are a celebrity signing autographs. Michelob Light had chosen some Playmates to go on tour, as did Budweiser. Those events were fun and exciting.

One of the most exciting promotions was called The Playboy United States Endurance Cup Racing Series. I always thought it was kind of funny that they called it The Endurance Cup because that's what we all look for sexually, *endurance*. But, this time it was with a different motor that had four wheels.

The guy in charge of it all for Playboy was Steve Goldberg, a noted sports writer. He had done stories for *Time* magazine and other publications. In 1984, Kym Malin and I were chosen by Steve to go to the Riverside Raceway in California to train at the Jim Ruffle British School of motor racing. It was a series, and Kym and I were the only two Playmates chosen. We had to learn how to race, and we each had to get a racing license in order to be the Grand Marshals for Playboy's Racing Series. It was pretty cool being the only Playmates in the racing school at the same time.

The guys were awestruck. One of the photographers was taking pictures of our every move. We were out there learning how to hit the apex of the turn and how not to get the RPMs up between gears. Kym was a hoot. I was really serious about it and I think she was fairly serious about it, too. But she would spin out a lot, but always emerge smiling. I actually thought at the time this would be a good career for me because I love to drive and I love speed, control and the competition, especially where it was against mostly men.

Kym and I did the whole series that summer from racetracks in Atlanta to Connecticut. Lime Rock in Connecticut, St. Louis, up in Napa Valley. We were the Grand Marshals of the entire series, we lowered the checkered flag, we got to hobnob with all the racing stars. We rubbed elbows with the likes of Sterling Moss and Inez Ireland, who were onetime Formula 1 racing stars. It was a pretty intense situation having to be responsible for the Playboy name.

In 1985 there was an FCCA sanctioned racing series and Playboy had their Playboy United States Endurance Cup. Playboy magazine was the title sponsor. There were four classes in that race and the purse was twenty thousand dollars with a year-end bonus of sixty thousand dollars. Kym and I were part of that series; it was fantastic.

"KISS" IN THE BIG EASY

I was doing a car show in New Orleans with other Playmates when the band Kiss was performing for one of their first times without makeup. Cathy St. George was new to Playboy and was good friends with Paul Stanley. She got us an invitation to the concert with limousine service to the backstage. We were treated like the celebrities we were at that time. We went backstage to meet the band, which was pretty amazing because Gene Simmons did his infamous thing with spit coming out of his mouth about two feet down, then sucks it back up. I was grossed out by it. I wasn't a really big Kiss fan and didn't know much about them, but we had front row seats. The concert was great, and afterwards we went out with the guys, Paul and Gene. We went to a nice restaurant in New Orleans and I was having a cocktail, a good time, yakking it up and getting buzzed. I kind of looked over and thought *Well these guys aren't drinking, what's up with this?* I found out that they don't drink.

Gene was hitting on me pretty heavy and, sure enough, I took him back to my hotel room and we had a pretty good time. He wasn't boyfriend material, but he was very intelligent, very intriguing and I guess he felt the same about me because we stayed in touch. He'd come to LA a lot and we would meet.

He didn't drive at that point because he lived in New York and took cabs everywhere. But he would sometimes come by my apartment and pick me up in a rental car, which scared the shit out of me because he couldn't drive.

My parents were in California visiting one day when Gene was coming to pick me up. I was so nervous that he going to come over in his leathers and look like this rock'n' roller. I told Gene, "My mom and dad are here and I'd like you to come up and meet them." He was so gentlemanly.

When he buzzed my front door and I let him in and he came up to my apartment, I opened the door and there he stood, in a khaki sports suit. I was cracking up. He came in and met my parents and we went bowling and then to Le Dome and had all the desserts: I had a sugar hangover the next day. Gene and I really did become friends after that. He would call me every time he came into town.

IN LOVE AND OUT WITH GENE

I was dating a hockey player for the Kings named Anders Hakansson. He would go back to Sweden every summer. He wanted me to move to Sweden, but I would have had to put my dog in quarantine and give up my career. I would have had to go to school to learn Swedish. I just wasn't up to that at my age, at the time. He was the love of my life, and I should have never let him go.

Midsummer Night's Dream, a Playboy event that has always been a great party, was coming up and I didn't have a date. Gene was coming into town and I asked him if he would be my date for the event. We went down to Rodeo Drive to get matching pajamas. I had a smoking jacket and he wore the pajama pants, but it wasn't very sexy. I never really dressed sexy in those times and I still don't.

Gene sent a limo, picked me up with my friend Kelly Tough, and we went to the Playboy Mansion. Everyone was flipping out that Gene Simmons was there. We were having a great time. I had a couple of cocktails and he was rummaging around having a good old time himself, but then, all of a sudden he disappeared.

I just thought it was kind of strange because he was always nearby when we went to parties. He was always like "Where are you, what are you doing, who are you talking to?" and basically following me around.

I found him in the bathhouse having a conversation with Shannon Tweed. I thought *Well, okay, that's fine,* until Tracey Tweed came up and she said, "Marlene, can I talk to you for a second?" Tracey never talked to me much before, so I thought it was a little strange. She asked, "Are you dating Gene?" I said no, we're just friends. She went okay, good. Then she ran away. I went back into the bathhouse and there was Gene in a heavy, big-time kiss with Shannon. It pissed me off because I thought it was rather disrespectful. I called for the limo and when it arrived at the front door of the Mansion, Gene came running up and he asked me what I was doing. I told him I was leaving.

I just thought it was pretty uncool of him to do what he was doing during our date. But, he was gentlemanly enough to get in the limo with me and escort me home. He turned around and went back to the Mansion and it's been Shannon and Gene from then on. He or his manager call me when they have a concert and he takes my son and friends backstage, which I am very happy about. I guess it was just one of those relationships where we will always be friends even though we don't talk that much anymore. C'est la Vie!

Marlene Janssen was born September 2, 1958 in Rock Island, Illinois and was the first born in America to her German immigrant parents. Her Centerfold was shot by Kerry Morris and Arny Freytag. She resides in North Carolina and calls it home. Her son is her absolute pride and joy.

Marlene is now working in the insurance industry with individuals, families and businesses, focusing on life and disablity insurance, retirement planning and business succession planning. She is still passionate about yoga, exercise, eating healthy and happiness!

Alana Sores –
Miss March 1983

THE BOLD PEEPING TOM

It was in the mid-80s and I was getting ready for the *Midsummer Night's Dream* party at the Mansion. I was taking a shower when the phone rang. Not wanting to miss the call, as I believed it was a girlfriend, I ran over and grabbed the receiver. Suddenly, as I stood there naked, phone in hand, I had such an eerie feeling wash over me. Through instinct, I looked at the bottom of my door blinds and there, in the half-inch gap between the floor and the blinds, was a pair of eyes staring in at me from the outside. I screamed and then dashed outside to scream at the assailant. As he frantically jumped from my balcony to the tree that he had climbed to get there, he apologized, "All I want to do is get a peek at you."

The tree that he had climbed was thick with branches and I was living on a second-floor apartment with my roommate, Debbie Nicole Johnson, who was Miss October 1984. The Peeping Tom had climbed at least thirty feet to get onto our balcony and get a view. We immediately called the police, but the peeper was long gone by the time they arrived. Debbie and I had the branches cut from the tree that led to the balcony. We thought we were now safe from peeping perverts. Not so!

One night Debbie was taking a bath, and she saw leaves rustling in the tree by the window. She screamed for me and I rushed in. She was so terrified she couldn't speak, but from her panicked look toward the window, I knew the Peeping Tom was back. I ran out onto our balcony and there he was: The Peeping Tom had climbed another tree and was standing on a branch thirty feet in the air. I started yelling at him, telling him we knew who he was and we had pictures, trying to scare him off so he would never come back. He let go of the branch, dropped to the ground and limped off.

Again the police came to our apartment. Even though I was scared to go down to the station, I went and was shown a number of mug shots. And there he was! The last mug shot. I pointed him out to the officer who responded, "I'm glad you said that!" Apparently, the guy already had a long arrest record and there had been numerous other complaints in the area about him.

A few months later, I went to the Mansion to work out. I often went there late at night because it had a great gym and there was rarely anyone else there. After the workout, I came home and as I walked up the stairs to our apartment, I heard someone walking behind me. I thought it was one of my girlfriends, and being the prankster I am, I opened the door to our apartment and hid the behind the door waiting to scare her. I waited and waited and waited but nothing happened. Finally I open the door there he was again – the Peeping Tom. "Who the fuck are you?" I screamed. And once again he apologized, "I'm so sorry! I have the wrong apartment." He then very calmly and casually went back down the stairs. I ran back inside, locked my door and call the police.

What struck me as so strange about the Peeping Tom was how well dressed he was. Oxford shirt, khaki pants, nice leather jacket. He looked like a very normal thirty-year-old guy. One would never think in a million years that he was a total pervert. When I described him to a friend of mine, she remarked, "I would date this guy."

Finally the police caught him and, of all things, he was an attorney. The police had arrested him after he was seen on the campus of UCLA watching co-eds undress in a dorm. When the police searched his apartment, they found a videotape he had made. The police asked me to watch the tape to see if I was on it. It was quite a harrowing experience. There were images of girls undressing with the background sounds of his heavy breathing. At one point on the tape, he was with a prostitute. He was telling her how he was a producer and wanted to tape her doing kinky things.

Debbie and I had to go to court twice, once for the criminal charges and once to get him disbarred. Thankfully, neither one of us had to testify. But we did hear his 95-year-old grandmother testify that he was with her during many of the alleged incidents, and his "fiancée," who looked to be another prostitute, testified he was with her. During the trial, the district attorney told me that the first day the lawyer was on our balcony was his first day of probation after a previous Peeping Tom conviction. Believe it or not, the court system failed. Later on I heard he had moved to Scott Valley in Northern California and was still practicing law,

but later withdrew from the bar and no longer practiced law.

To this day, I still am constantly looking over my shoulder to see who is behind me!

THE PURPLE ONE – PRINCE

I went to a club called Vertigo with a fellow Playmate who had been with Prince for a while, but had since split up. Prince just happened to be at the club that night. My friend introduced me to "the Purple One." Let's not forget, when you are a Centerfold you get spoiled always being introduced to celebrities.

Everyone was ogling Prince at this club and after being introduced to him, I thought *What's the big deal with this guy?* Just as I'm discussing his stardom with his ex-girlfriend, I turned around and there Prince was. "Would you like to dance?" he asked. It was like the parting of the Red Sea as we walked onto the dance floor. But it's difficult to enjoy a good dance when everyone is staring at you.

After the song we sat. Prince did not talk much. He wanted me to do all the talking, and I obliged. Finally he asked me if he could get my number. It was Prince! How could I say no?

I offered him my number, but he told me his bodyguard would get it from me and a moment later, he was gone. His bodyguard approached me and I told him my number. The bodyguard did not bother to write it down, but assured me, "Believe me, I'll remember it. It is part of my job". I stayed to dance some more and have fun, even though Prince had left early. When I left the club forty-five minutes later, I saw his limo parked outside. I walked to my car and as I pulled away, the limo pulled away also. It seemed that Prince had wanted to make sure I had left the club alone.

Before going home I stopped off at the Mansion with a fellow Playmate to get a bite to eat. When I arrived home around three that morning my roommate was still up. "Alana, Prince has been calling you," she told me. The phone rang again a half hour later and it was Prince's bodyguard, the same one from the club that night. "Is this Alana? Hold on, I have Prince for you," he said. I heard the phone click and awaited the Purple One. "Are you

okay? What took you so long to get home?"

I explained about the trip to the Mansion, and he asked me out on a date. Naturally, I was very flattered, especially with Prince's history of dating the most beautiful women in the world. I knew he was a player. But everything seemed so surreal: a date with Prince.

A few days later I was waiting for Prince's limo to pick me up for our date when the phone rang. It was Prince. He asked me if I wouldn't mind wearing something yellow. I wouldn't have minded but I didn't have any yellow clothes, only a nice gold top. He told me it was no big deal. The limo arrived and took me to Prince's house where he joined me in the limo. We sat facing each other and he was very pleasant, complimentary and charming. We went to the Bistro Gardens where he jumped out, and asked me to wait a moment. He came back after fifteen minutes and asked if it would be okay if we ate at his home because his private table was not available at Bistro Gardens.

Prince's house was quite amazing. We sat at a long, long table with each of us at opposite ends. There were candles everywhere burning brightly. During the meal prepared by his personal chef, Prince collected his place setting and walked the length of the table to join me at my end. He sat by me and fed me for a while. After dinner he showed me his home and his incredible bathrooms. He told me he loved basketball and showed me his personal basketball court. He confessed to me he sometime played in his shoes – his high-heeled shoes.

Prince was very witty and had a great sense of humor. But I could never tell when he was pulling my leg. He was almost like a little kid. And we had some bizarre conversations:

Prince: "Would you ever want to be my girlfriend?"

Me: "But Prince, I don't even know you. How do I know you're not going to be dating everybody else?"

Prince: "You wouldn't!"

Prince: "What kind of car do you drive?"

Me: "A white convertible Rabbit."

Prince: "You'd look better in a black Jaguar with red interior."

It was so overwhelming. I was intrigued by him and attracted to his mystique. But I was not going to sleep with him just because he was Prince.

The evening ended when I told him it was time to go home. He gave me a kiss on the cheek and, as the limo started to leave, he asked if he could see me again. I wasn't sure if he was serious or not, so I told him I would call him. Prince did call me the next day and left a message. But I never called him back. I would never be one of the "players" in the stable.

Alana Soares was born on February 21, 1964 in Redondo Beach, California. At the time of her Playboy shoot, she was majoring in political science at the University of Utah. Later on she finished a degree in communications with a minor in cinema from the University of Southern California.

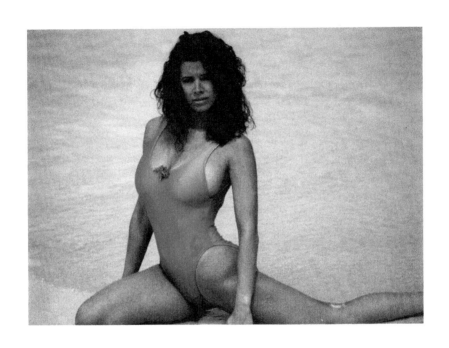

Patty Duffek –
Miss May 1984

All photos used with permission by Patty Duffek

HOW I WAS DISCOVERED

In 1983 I took some modeling classes. I was hopeful something would come of it, but I had not received one call for an audition. I figured I was scammed or, as we say today, "duped" by the modeling school. Then there was an ad in the newspaper saying Playboy was in town. The magazine was looking for their 30th Anniversary Playmate. I thought about it, then thought I would never get picked, and if I did, could I actually do it? I called the phone number. Playboy answered, and I hung up. I waited five minutes and then called again. Little did I know, that phone call was a life-changer.

Playboy asked me to come down to the Hyatt Regency for a few pictures. I headed to the Hyatt on that sunny, 100-degree day. The summer of 1983 was soon to be quite interesting. I was a nervous wreck. I had never even modeled, and now this.

The Playboy staff was really friendly. I met with photographer David Mecey, and he took a few pictures. They said they would get back with me. Surprisingly, I received a call that night. I was asked to come back the next day for a mini-photo shoot. Things happened superfast.

A couple weeks later I was working at Pioneer Chicken. I was told I had a phone call from a lady named Bunny. I thought, *How odd*. Bunny explained she was from the Playboy office in Chicago. She invited me to go to LA for a shoot because Playboy was interested in me becoming a gatefold. I asked, "What is a gatefold?" I was quickly told it was a Centerfold. I was in complete shock.

I was flown out to Los Angeles two weeks later, picked up in a limousine, and taken to Playboy Mansion West. I stayed there a few days while I was testing. On the final day one of the editors told me "Hef really likes you." But, I flew back home and thought that would be the end of it. I looked at it like a fun little vacation.

A few weeks went by and I received another call from Playboy asking me to come back to start shooting my gatefold. And, yes, this time I understood what a gatefold was! My gatefold and pictorial took a couple months off and on. I was told that I and five other girls were finalists for the 30th Anniversary Playmate. I ended up being chosen Miss May 1984.

I believe that timing is everything. I think I was at the right place at the right time. I was discovered quickly and appeared in the magazine within a year.

PSYCHO-COP

In 1993, I was getting ready for my night class when a police officer showed up at my door. This policeman looked a little familiar. He made mention of the fact that he worked at a Pioneer Chicken years ago. The policeman went on to tell me that I was being followed and stalked by someone very dangerous. I got a funny feeling from this conversation; something didn't sound right.

A few months went by and I saw him hanging around my apartment complex. This psycho-cop had moved into my apartment complex. Every time I turned around he seemed to be there. He kept telling me stories about how I was lucky to be alive. He was on sick leave, I later found out. I felt harassed. The worst was when he told me I was supposed to be kidnapped and held for ransom until Hugh Hefner paid the "bad guys" a million dollars. *Psycho-cop* was the bad guy.

I had a meeting with two investigators from police internal affairs. These men were not helpful. "To Protect and Serve" – NOT!

I went to my car one afternoon. I had a flat tire. There was psycho-cop waiting to "rescue me."

I became a prisoner in my own home; psycho-cop had become delusional. He believed he was my "savior" when the whole time he was the stalker. I ended up seeking out the help of a civil rights attorney, because I was the lightning rod between a psychotic policeman and the police department.

I finally moved, and kept a very low profile.

A while later, I saw a picture of this psycho-cop on the news. He was involved in the kidnapping and murder of a Wells Fargo driver. Psycho-cop and two other men had taken a million dollars from an armored van. The story really disgusted me. The nightmare ended. The man who swore to uphold the law was now where he belonged – behind bars.

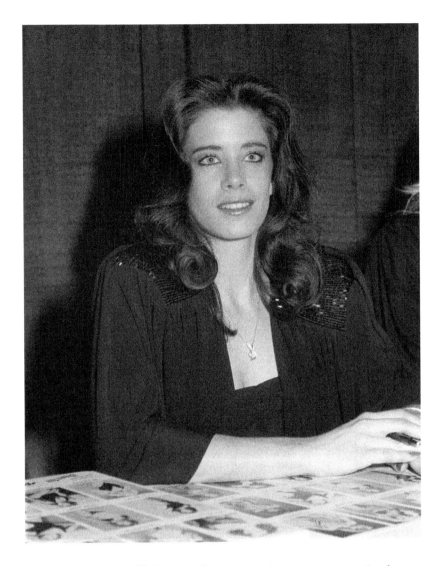

Patty Duffek was born on August 27, 1963 in Woodland Hills, California. She graced the pages of Playboy as Miss May 1984. She has been in numerous films including Hard Ticket to Hawaii; Picasso Trigger; and Savage Beach. She has a bachelor's degree in social work and minored in psychology. She graduated Magna Cum Laude from Arizona State University. A true American model.

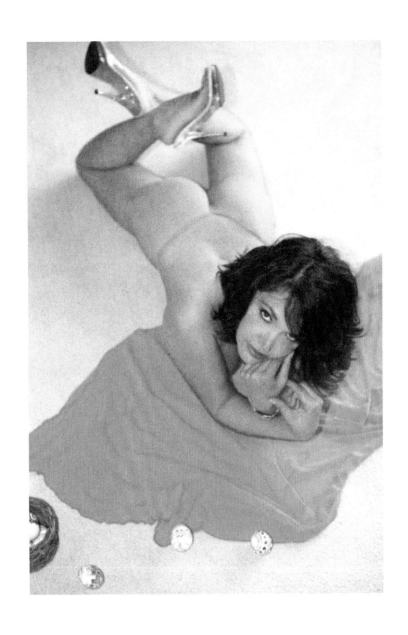

Devin DeVasquez –
Miss June 1985

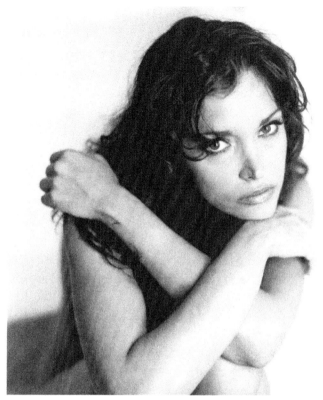

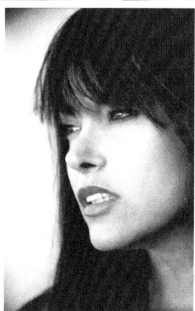

All photos used with permission by Devin DeVasquez

Discovering the Pinup Inside Me

In 1981, I was attending LSU as a freshman and studying marketing and accounting. Playboy magazine was something I'd never seen because I was only 17: I had graduated a year early from high school. That year Playboy put a huge ad in the LSU newspaper looking for girls for their "SEC Pictorial."

Everyone was familiar with the famous bunny head logo, so Playboy's quest was talked about greatly on the local news. Apparently, Playboy rarely came to the Deep South to look for girls to pose nude in their magazine. They frequently toured the campuses of Florida and Texas, but Louisiana was a bit too religious for the still-controversial magazine back then.

I was still very much a teenager, but I was all alone due to the fact that I grew up in and out of foster homes. My mother had a nervous breakdown when I was only five years old and my real father passed away before I was born. So, I knew from an early age that I would have to take care of myself and, to do so, getting a college education would be pivotal.

I was working two part-time jobs and taking a full load of college classes when Playboy was visiting LSU. I had classes from seven-thirty to noon, and then I would work from twelve-thirty to four-thirty in an office on campus before getting to my next part-time job as a cashier in a department store from five-thirty to nine.

My days were filled and I had nightly homework to boot. So, as other female students started talking about Playboy magazine looking for girls to pose nude for their famous "SEC College Pictorial," I began to get curious as to what all the fuss was about. I followed a fellow student to the building where photographer David Chan was taking Polaroid photos of girls in swimsuits.

David was a small Chinese man with big black-rimmed glasses. He had a little long-haired dog named Mei Ling that he carried around with him. Girls were lined up and filling out forms, waiting for David to take their photos.

When I walked into the room, my attention went to Mei Ling, the Lhasa Apso that seemed to be so calm and quiet throughout all the chatter from the girls trying on bathing suits. David

looked me over and asked if I had my bathing suit on, which startled me because I was there as an observer, not a participant. When I told him "no" he asked why not? He then proceeded to give me a bathing suit to try on, and so I did. When I came out of the room with my suit on he told me to stand on the taped X area and he proceeded to take a few Polaroids. He told me to smile with my eyes.

It was all a bit foreign and new for me to even be there, and when it was over I was more than curious to see a Playboy magazine. Since I couldn't buy one and wasn't 18, I asked my girlfriend JoNell, who was eight years older and like my big sister, to buy one for me. I had met JoNell when I worked at the department store and we became fast friends. She had an apartment near campus and had offered to let me stay with her until I moved into the campus dorms that year. I was forever grateful for her kindness, and she became the big sister I never had. So I couldn't wait to tell JoNell all about my photo shoot with David Chan that day. She actually thought this was a good opportunity for me and purchased the magazine for me to view. When I glanced at the Centerfold, my jaw dropped in shock over how gorgeous the women were, and of course how nude they were.

When I had filled out the form for my photo shoot with David, I was merely asked a few basic questions about myself. I was also asked if I would pose fully clothed, semi-nude or fully nude. They paid one hunded dollars for fully clothed, two hundred fifty for semi-nude, and four hundred for nude. I didn't think I could pose nude, so of course I said "fully clothed" and I didn't think I had the slightest chance of being one of five girls that they would pick out of the four hundred who had tried out.

I was stunned when I got a call from David two months later. He told me I was one of the five girls they chose and wanted to know if I would pose semi-nude instead of fully clothed because I had such nice boobs. This was indeed a shocking phone call, and I felt like I was put on the spot to give him an answer right then and there. I asked if I could think about it and get back to him. He told me he needed my answer by the next day. So I called JoNell to help me with my decision. I could pay for an entire semester by posing semi-nude and would not have to work

so much, so that was weighing heavily. JoNell thought it was an excellent opportunity for me to maybe do some more modeling and help earn more money to put myself through school. So, because I had her support and had already seen a Playboy, I made the decision to pose semi-nude, which meant topless.

David was very pleased and told me that his makeup artist Sheryl would be in touch to give me a call time for hair and makeup; and they would be taking me out to a plantation for a the actual photo shoot. It all seemed exciting, yet scary because I didn't really have any idea how to model,

We began our shoot in the early morning hours on a Saturday, so it would not interrupt my regular schedule. I sat in the makeup chair while Sheryl made me look like a goddess. There was only one other person in the room with David setting up lights as we began to shoot. I became very shy about taking off my robe and revealing my natural breasts in front of three strangers. But, I had agreed to do it and so I took off the robe and stood there while David directed me to put a rose in my hair, and started shooting what seemed like an endless number of photos.

I quickly became more comfortable being topless when I saw David's assistant reading a book, while David continued to tell me to smile with my eyes. It was clear they didn't care so much about my nude body at all. After a while we stopped to have lunch, and then it was back to taking more topless photos. I swear they must have taken hundreds of photos that day. I remember Sheryl saying, "She's got boobs like a Playmate." I asked, "How much do you pay Playmates?" David replied, "Twenty thousand," to my surprise. "But you have to take all your clothes off."

I knew there was no way I could do that at the time. It was an ordeal getting through being just topless, but the compliment about my boobs being like a Playmate's was enough to give me an extra boost of confidence.

After a long day of shooting we were finally wrapped and I was amazed at how tired I felt, but was really excited to see the finished photos. I still could only see Polaroids, and the film would go to Playboy for their review. All this to pick just one shot for the magazine seemed amazing.

David and the crew wanted to go for a drink on campus and I informed them that I couldn't drink because I wasn't yet 18. All of a sudden, panic took over the energy of the room and Sheryl scrambled to find my application. They just assumed I was 18 because most college girls were. I explained how I had graduated a year early from high school and they explained how they needed a parent's signature to use the photos that they had already shot. When I told them I didn't have parents and I was on my own, they said they needed a guardian's signature and I suggested JoNell, who happily signed their forms for me. It turned out because I was turning 18 that summer and the magazine wouldn't come out until October, we were okay. I think after my experience, Playboy started asking for photo IDs.

The controversy of that one photo appearing in the October 1981 issue of Playboy cost me greatly. I lost my student job with the state department of revenue. I thought this was hypocritical, since they had to buy the magazine to even know I was nude, and besides, I was a terrific student worker. There was an LSU cheerleader who posed fully clothed, in her uniform, who was kicked off the squad for posing. So this experience immediately showed me how narrow-minded the Deep South could be, and, ironically, it fueled – rather than discouraged – my desire to be a Playmate.

It would take me two years to muster the courage to call David and try testing for Playmate... after all, I did have boobs like them.... At the time, you didn't see many exotic women in the pages of Playboy. They had their signature blonde bombshells that dominated the magazine back then. David remembered me and told me I should come to Chicago to test and meet the editors in person. He fronted me a plane ticket and told me I could pay him back when I became a Playmate. So, with fifty dollars in my pocket I headed to Chicago in the fall of 1983 – with hopes of becoming a Playmate.

David introduced me to the editors who gave him the approval for a test shoot. I shot my test in the Chicago offices of Playboy studios and David explained we had to wait a while for the editors to view them. The process would be long, and the next step would be a gatefold shoot. While I was waiting, I told him I would get a job as a waitress and pay him back for the

plane ticket and for rent to stay at his place, since I didn't know anyone else in Chicago. David traveled quite a bit for Playboy at the time and was happy to help me by giving me a place to stay and said I could pay what I could for the time being.

I guess luck was on my side because within a couple months, I was approved for a gatefold. I had been working as a waitress with another girl who had already shot a Centerfold and she had been waiting for two years. I was hoping my selection would come much faster. I got my wish and my Centerfold shoot was scheduled with Richard Fegley, but I was sick with the flu the day of the shoot. However, I was more than determined to get through it. Even though my eyes were watering and I was drinking Vicks cough syrup through a straw and trying not to cough during poses, standing still for the 8 x 10 negatives that were shot for the Centerfold, I ended up shooting my Centerfold in one day.

A few weeks later I was told I would be Miss June 1985. In fact, I was the last Miss June with staples in the magazine centerfold, and the only Miss June that didn't have the Playmate of the Year pictorial in it. Karen Valez was the Playmate of the Year, and since our last names were Hispanic, they put her in the May issue with a blonde Centerfold.

I quickly discovered this decision would forever change my life and I would be a part of an elite group of women, as well as a part of American history. I also discovered that unique pinup girl inside me who eventually turned into a seductive woman. I don't regret my decision to pose nude: it made me who I am today, and it's really cool to see future pinups who have been inspired by my career. I had the privilege to interview the legendary Bettie Page for my book, "*The Naked Truth About A Pinup Model.*" I told her how much I admired her modeling and what she did back in the 50s for models like myself It has been the highlight of my pinup career to interview Bettie. She told me I was the only woman in her line of work to ever interview her. So, if I can pass that baton to a girl who has dreams and aspirations for a pinup career, then so be it. Go for it! Live out your dreams, and dream big because dreams really can come true!

How I Met My Husband

When I came to Hollywood it wasn't because I wanted to be an actress. Quite the contrary, I was competing on a talent show called *Star Search* as a model. It was the first time you saw models speak on TV and introduce other acts such as singers, dancers and comedians. *Star Search* was one of the first reality shows.

It was a very big deal to be chosen for *Star Search* because it seemed there was a cattle call of models in every city that wanted to be on that show. I was lucky enough to win one hundred thousand dollars in 1986 as the champion spokesmodel, and I had agents asking me to sign with them for commercials. A television show was the next logical step.

I had just moved to Los Angeles from Chicago and was already a Centerfold. Playboy was doing a celebrity feature pictorial on me with a cover. This was huge for me as one of the first Hispanic Playmates, and because I had been shortchanged by not having the Playmate of the Year in my month.

I had been going to the hot nightclub called "Tramp," which was located in the Beverly Center. One night I was dancing and wearing an all-white outfit when this heavyset man holding a cigar approached me. He was the epitome of what we all think producers are supposed to look like. He was enthralled with my outfit and asked me if I was an actress. I had never even seen a script before, but I did have an agent and I had only been in town for a few months. When I told him who my agent was, he got excited and claimed his leading lady was also with my agent and that he was going to put me in his movie. I swear I thought he was just talking nonsense and I didn't believe him, but sure enough, he called my agent. She told him I needed my SAG card so he would have to to give me a line so I could qualify for the union.

Anyone who is an actress, or has tried to be an actress, knows how important and difficult it is to get a SAG card. And I got mine within a few months with absolutely no idea what a script was or what was about to happen. I was told by my agent to go to the set in the same white outfit I wore when the producer

met me. I was told I would be dancing in a nightclub scene and would be given a line and would then get my SAG card so that I could get more speaking roles in movies. So I did as I was told, and knew nothing about the movie except the title, *Hot Child in the City*. There was a song with the same title that would be the theme song for this movie.

I did a little dancing, and then the producer had wardrobe change me into another dress. He then had me walk by the guy sitting with his back to me at the bar and say, "Hi, Tony" and walk off. This guy was getting ready to do an intense fight scene with another guy whose face was painted half like a man and half like a woman. I was never introduced to this guy and I never saw this movie, but I went home and had my SAG card.

Well, 18 years later actor Lorenzo Lamas was on the TV show, *The Bold and The Beautiful,* and he reintroduced me to its star, Ronn Moss. I had met Ronn briefly at a wrap party for a movie that his now ex-wife and my then-boyfriend did together back in 1987. Ronn and I hit it off and started dating in 2004. After dating for about a month I noticed the movie, *Hot Child in the City,* on his résumé and told him I got my SAG card with a one-liner on that movie. He told me he had met his now ex-wife on that movie. It turned out Ronn was the guy at the bar that I said hello to, the one who was getting ready to fight the man with the painted face. Who knew that guy would end up being my future husband?

Devin DeVasquez was born on June 25, 1963 in Baton Rouge, Louisiana. Her Centerfold was shot by Richard Fegley. She appeared in "Can't Buy Me Love" with Patrick Dempsey and went on to star in "Society" with Billy Warlock. She married Ronn Moss, who played Ridge Forrester on the CBS series, "The Bold and the Beautiful". Devin and Ronn live in the Los Angeles area.

Kat Hushaw –
Miss October 1986

GUESTS OF THE ISLAND KING, TOM SELLECK

In 1987, fellow Playmate Julie McCullough and I had a rare opportunity. We traveled to Hawaii as part of a nine-member Playmate Softball team to compete in a charity game against the crew of the TV show *Magnum P.I.* It wasn't a very pleasurable vacation, as we worked nonstop from six in the morning until ten at night every day, making personal appearances, doing radio and television interviews, as well as the playing game itself. There was little time to relax, let alone explore the beauty of our surroundings.

On the final night of our whirlwind trip, Tom Selleck hosted a dinner for the Playmates as a "thank you" for our participation. At the dinner table he overheard Julie and me lamenting our lack of free time for sightseeing and fun. As the group was leaving the restaurant, Tom pulled us aside and suggested we stay. We said we couldn't afford accommodations and didn't know anyone there. Tom offered to help: he knew of several vacant hotel suites reserved for guest stars on the *Magnum* show. He handed us a business card and told us to call his production company in the morning.

The next day I nervously dialed the number. To my utter surprise, a suite had already been reserved in our names. Two hours later we were picked up and driven to our new home, the Colony Surf Hotel. While the rest of the Playmates were flying back to the mainland,after a brief and exhausting visit, Julie and I were guests of the *King of the Island*.

Our hotel suite was a dream – eighteen floors up and right on the beach. We had an outdoor terrace the size of my living room back home, two huge king-size beds, and a Hollywood "glamour queen" bathroom that was probably twelve hundred square feet.

We were excited, exhausted, and overwhelmed; we plopped down on our beds for a rest. The phone rang and it was Tom. Did we like the room? Would we be interested in joining him for dinner that evening?

Were we dreaming?

Of course we agreed to have dinner with him and when the phone called ended, we literally squealed with delight. It was as if we had pulled off some major coup. That night, after dinner at a fabulous Italian restaurant, the three of us went to Tom's home on Diamond Head.

He asked us about our lives, families and dreams. He could have used his celebrity to seduce us, but he proved to be a man of depth and soul.

For the next three days we explored Honolulu like tourists. We became friends with a few locals who showed us lesser-known parts of the island. They had no idea who our host was. Every evening Tom would phone us to make sure we were taken care of.

Before the taxi came to take us to airport, we left a message with Tom's production company thanking him for his incomparable hospitality. As our plane lifted off, I watched the Hawaiian Islands landscape recede behind us. I knew that someday I would return, albeit under different circumstances. This had truly been a once-in-a-lifetime experience. I wondered if anyone back home would believe me. I could hardly believe it myself.

Kat Hushaw was born on October 23, 1963 in Anaheim, California. She now lives in the Los Angeles area designing her own jewelry

Carmen Berg –
Miss July 1987

All photos used with permission by Carmen Berg

GETTING STARTED

I was born and raised just outside of Bismarck, North Dakota. I spent my childhood caring for my pets: my dog, cats, piglets, calves or donkeys. They were my buds. I was very quiet and quite shy, so shy that I never became involved in any school activities. I remember the dreaded days of cheerleader and pompom tryouts. I was nowhere near getting chosen. Parties? God forbid! They might be pool parties. I hated the way I looked in a bathing suit. I was like a fly on the wall at social events because I didn't drink or smoke or have sex. Somehow I managed to survive high school and graduated at the age of 17 with honors. My whole life was ahead of me!

The problem, I thought at the time, was: what kind of life could I make for myself in North Dakota? So, like a lot of my peers who probably didn't have the answer, I entered community college. I found myself daydreaming out the window most of those two years, feeling like there was something better than this, something that would figuratively light my fire – because I knew I didn't fit in where I was.

In the winter of 1984 after looking at a Playboy magazine, I talked my boyfriend into taking nude snapshots of me. I still remember having the Playboy magazine open on the floor by bed, while I was trying to pose. Somehow we did the photos and survived the embarrassment of taking them to the local photo lab. I sent the photos to the Chicago address listed inside the Playboy magazine and a few days later when I came home from work, there was a call from a Jeff Gordon of Playboy. I just about died! It was the jolt my life needed! Jeff wanted me to fly out to Chicago for a Playmate test shoot. In a few days, I was boarding the plane in Bismarck, North Dakota, heading into the unknown. I had no idea what to expect. I was scared from all the stories I had heard about the sex, drugs and alcohol relating to Playboy, and the idea of cults and sex slaves even crossed my mind. But, being a headstrong, free-spirited pioneer from North Dakota, I felt the unknown was alluring and my curiosity won out.

I was picked up at O'Hare International Airport in a black stretch limousine. It was a far cry from the Ford Escort that had

dropped me off at the airport in Bismarck. I was driven into the city of Chicago. I still remember it was evening rush hour because I could never imagine there were so many cars in one spot. The magnitude of it all made me feel like a speck in this world. I remember driving over the bridge on North Avenue and Alston Street and looking to my right and seeing this breathtaking view of the Chicago skyline. I knew right there and then I was meant for the big city.

I didn't get much sleep that night. The next day I walked next door to the infamous Playboy building located at 919 North Michigan Avenue. I rode the elevator up to the 12th floor and the door opened to these beautiful nude photographs. I'm thinking to myself, *What the hell you are doing here?* Somehow I propelled myself forward, and the next thing I knew, I was in a chair having makeup applied to me.

David Mecey, the photographer taking my pictures, and his assistant and I took a cab over to a beautiful high-rise apartment on Chestnut Street overlooking Chicago. For Playmate test shoots Playboy rents out people's apartments by the day, because their own Playboy studios are in use by photographers shooting Playmates. David gave me a blue chemise and showed me to the bathroom. I put it on, but couldn't get the courage to come out until he was knocking on the door wondering if I was okay. What started out to be a laborious process turned into something quite fun and magical. The day flew by and I really enjoyed the process of creating the pictures. David and I became good friends that day, a friendship that lasts even today. He was so sweet to me. We even went out to dinner afterwards and he took me back to the Playboy offices to fill a mock Playmate data sheet. I felt so comfortable now, a far cry from the twelve hours earlier when I hadn't even wanted to get off the elevator. That night, I slept like a baby. All those fears I had just a day ago now seemed so silly.

The very next day I was back on an airplane and home in Bismarck, North Dakota – I was changed forever. There I waited for an answer. It didn't take but a few days when Michael Ann from the Chicago Playboy office called and said I just didn't have what it takes to be a Playmate – a definite blow. But my appetite had been whetted and I liked doing the pictures, so I focused on

having a career in modeling. I moved to Chicago and started at P.S. Chicago on Rush Street as a cocktail waitress, even though I wasn't yet 21 years old. I started picking up modeling jobs during the day. The sting of being rejected as a Playmate finally had worn off, so I went to Playboy Models where they signed me to do regular modeling assignments outside of Playboy magazine.

One day, while I was sitting in the waiting room at the Playboy modeling agency, a strikingly handsome older man walked over to me. It was Pompeo Posar. He started talking to me and asked if I would do a Playmate test. I thanked him and told him I had already done one and had been rejected. Pompeo, being his charming self, convinced me he would take the pictures of me that would not be rejected.

We did the test, and to my total surprise they were accepted. Now began the long process of shooting my Centerfold. We finished it in about a week, but I wasn't happy with the results. I wasn't happy with my clothes, how my hair was done or my makeup. Not to my surprise, the shoot wasn't approved by Hefner. Strike two!

I went back to modeling and was going to do quite well with posters, calendars, catalogs and magazines. I was happy. Then Pompeo started booking me for little photos in the Potpourri section in the back of Playboy magazines, which was handled by Bruce Hansen. I was able to make a little money and Pompeo would take extra film of me to compile a slide portfolio. He still talked of making me a Playmate and at that time, Bruce and Pompeo were my biggest fans. Pompeo became a great mentor to me and gave me the extra confidence I surely needed.

I quit my job at P.S. Chicago and moved over to a few nights a week at the Chicago Playboy Club. I liked being a Bunny. I still remember my suit which was baby blue to match my eyes. Then one day, the call came: They invited me to try again to be a Playmate. I wasn't sure my ego could handle a third rejection. But the other side of me thought, *I will never know if I don't try.* So I did. Pompeo had a beautiful set built for our shooting and talked to me about what I would like. I told him I liked it very natural and simple. Out of this shoot came my white robe Centerfold that Hef did accept.

Carmen Berg was born August 17, 1963 in Bismarck, North Dakota. In 1993 she created a Chicago-based consulting firm for models, actors and other creative people. She now resides in Los Angeles, California where she is a very successful real estate agent.

Cindy Guyer –
Celebrity Pictoral March 1999

All photos used with permission by Cindy Guyer

PLAYBOY AND THE FIRST SHOOT

Playboy saw me on *Entertainment Tonight* and when they called me to see if I would do a pictorial shoot, I wasn't sure. I had been on something like two thousand romance novel covers. I had a boyfriend at the time who told me if I did Playboy he would break up with me. Well, after we broke up I thought, *I'll do Playboy* and it was a good move. I called them and said, "Yes, let's do it."

I had actually gotten a couple of offers to do a shoot earlier in my career. People back then were much more conservative than now. Marilyn Grabowski and Steven Wayda took me to lunch and we talked about the theme of my shoot. We were going to do this amazing fairytale shoot; it was supposed to come out in February 1999. They thought it would be really neat to take all these novels and re-create them in life. They let me put on my creative hat, which I love doing. They were willing to do anything I wanted. So we went to Santa Barbara and got ready to do our first shoot; it was going to be Lady Godiva.

I got on this horse, "Crazy Horse," and it bucked me off in the middle of the shoot and I flipped over butt naked, only wearing hair. The second time I got on, he took off and if I hadn't off jumped, he would have taken me over a hill. I jumped off and fell naked into poison oak. I was saying to myself, *I can't ruin this whole shoot, there were so many people involved, so much money invested.* They did not spare any expenses. I knew if I had a neck injury or poison oak, it would really come out the next day. So I said "Listen, get me a bottle of wine and let me see if I can keep shooting." We did, we shot *Rapunzel, Let Your Hair Down* at a really cool house we found. Then we did my *Interview with a Vampire* shoot with these horses at another amazing house we found.

The next morning, we started at four a.m.. I knew when I woke up that my neck was unable to move from the fall, and I had poison oak all over me. Make-up artist Alexis Vogel said, "I

am not touching you," and I said, "Well, that's ok, I can't move my neck anyway." So we wrapped the whole photo shoot. I felt awful, but I am a trouper and the show must go on – that was in San Isidro Ranch.

If we had really done the photo shoot the way I wanted, the pictures would have been even more fabulous. The pictures with the location would have been stunning had I not been thrown from Crazy Horse. I was put into the next issue and Playboy built an amazing castle for me downtown in Santa Monica at PMW studio. It was beautiful, but I mean the location pictures would have been more amazing. The overall look was great in the layout and I was very happy with it, but it could have looked better. I had to take pain meds, was a bit bloated and my knees were all banged up, and I had cuts and scrapes all over me.

CHANGING THE THEME

Then they started changing the theme. One of the first shots we did had five thousand roses. I was to be naked and they shot it from a ladder looking down. It was tough because I was lying there on freezing cold roses; the roses had to be nice and perky, so they kept spraying me and the roses with ice cold water. It was three hours, very painful, but the most amazing picture I have ever done. It would have been on the cover, but they did not choose it. Gene Simmons ended up on my cover, which was actually a lovely thing because I got to know him. I ended up producing a show called *Mr. Romance*, and if I hadn't have done Playboy I would never have met Gene and I would have never gotten my show on *Oxygen*. As tragic as it seemed, it was a good thing because I got my own TV show.

FAMILY VALUES

When I did Playboy, my mother would not talk to me for about six months; she was very old-fashioned. My father thought it was cool, no problem, but my mother kind of disowned me. Eventually she understood why I did it, but at the time she was

mortified. As I got older she forgave me, but she always wanted me to be the good girl with the *Cindy Dolls* which was my own line of dolls on QVC. She wanted me to be the perfect little doll, but nobody's perfect, especially in this industry. Mom passed away a few years ago.

Photo by: Con Air 2005

Cindy Guyer has been a model on over 2,000 romance novel covers, and in dozens of national commercials and numerous films. She is also a successful restaurateur.

Photo by: Con Air 2005

Arny Freytag –
Celebrated Playboy Photographer

All photos used with permission by Arny Freytag

BORA BORA SHOOT

Jayde got the flu or some kind of virus, and we're in the middle of nowhere, an outer island called Bora Bora. There's one doctor in town, a French doctor. We take Jayde to a clinic, just outside of a canal, and it's basically patients sitting in the room with chickens used as currency to pay the doctor. The doctor comes out and takes Jayde to a little room. He goes to give her a shot and her pants are down. All of a sudden, the doc goes running out the office with a gun and starts shooting outside into the canal. He left Jayde with her pants down. It was unbelievable. Turned out there were all sorts of rats around that the doctor and his son used for target practice. The doctor had looked out the window and had seen a rat, so he burst out of his examination room to chase and shoot it. So, here is this doctor, running through the clinic with a gun. All these people were ready to pay him with their livestock, and then this Playmate is sitting with her pants down around her ankles.

MEXICO

We were in Mexico doing a Playmate layout and we're expecting beach weather in Cabo San Lucas. But a hurricane came in and all the roads to the airport were closed, and they closed the airport for two weeks. We had no rain gear and nothing to do, *nothing*. We couldn't leave the hotel, so we cut holes in garbage bags to use as rain gear. We went to the bar and drank all day and night. When we finally did get out, my editor wanted to get a picture. I guess the federales made a deal to allow us to use a military airport. So they flew in small planes, but the whole area was protected by the military. My editor had talked to the airline and wanted to get a picture of the Playmate standing outside one of the planes. We went up there to do the

shot and I told everybody, no problem. One of the military guys had a huge machine gun, an M-16, and he asked if he could get a picture with the girl. I said, "Sure." I had a super long lens on my camera and I was about fifty feet away. I put the camera up and I look at her and she's got the gun pointing right at me. She has the gun, not the guy, I'm going, "are you..." and the M-16 is pointed right at me. STOP, STOP, STOP... we don't want this. That's Mexico for you: anything goes.

ACAPULCO

We were in Acapulco and I wanted to shoot the girl in thigh-high water in the ocean. I asked her to go into the water just up past her knees.

She says, "I'm not going out there."

I ask, "Why?"

She goes, "There's whales out there."

I say, "Yeah, I am sure there are: it's the ocean."

She then says, "Well, I don't want to be close to a whale! They are huge animals."

"I'm only asking you to go up to your knees."

"Oh, no, no. When I flew over in the airplane I looked down and I could see whales. I am not going in that water! I don't want to be attacked by a whale."

She wouldn't go in! "What do you mean you won't go in the water? We're in Acapulco, for Christ's sake! The whales are fifty feet long or fifty feet in diameter or something, and it's not going to wash up next to your foot!" I can't yell at the model because I have to maintain a rapport. As a photographer I had to learn patience, and at the same time I have to be careful because I can't let them know the whole idea. I was very patient....

RUSSIA

I was in Russia shooting a Russian Playmate. I'm in the street with a sweatshirt on, wearing jeans and holding my camera. It was really overcast, so I was just waiting there for the clouds to clear, and a really old Russian woman comes by in a *babushka*, comes up to me and starts yelling at me, hitting me in the arm. I had an interpreter, and I ask, "First of all, why would this woman do this? I could just knock her to the ground."

He says, "You're not going to do that because there are secret police everywhere, and you're being watched right now." I go, "oh, okay." And second, she's yelling at you because she's saying that her life is ruined because you Americans brought democracy in to Russia. And she had it all free all these years: free apartment, free food. Now she has to vote for it." She was blaming me because I was American; it was my fault that life had changed. I thought that was really bizarre.

In Moscow I bought what I thought was a fake religious icon; it was a silver cross and picture. It had a cross and a picture of Jesus on it, and I assumed it was fake; I bought it from a church. I went through customs, opened my suitcase and they saw it, and customs called all these guys over. There were four guys with big Russian hats, the big military hats and uniforms with gold bars on their shoulders. They're all yelling at me.

It turned out, my souvenir was a real religious icon, and it's against the law to steal or take a religious icon out of the country. It is a very serious offense. I just wanted to get on my plane, which was going to Iceland. But the Russians kept saying "It's part of their art! You're not going on the plane. You are going to jail."

So, I said, "Do you guys like Playboy?"

They said, "Oh, love Playboy, love Playboy!" At that time I had all of these pictorial rights for everything. So I had Polaroids of every shot I do so I could keep track of what I have and what I need. I always pasted them in a little book, a binder, which I pulled out. I tell them that I am a Playboy photographer; this is what I have been doing in Russia. All of a sudden I'm like a hero.

"Oh, okay, don't worry about religious icon, that's fine," they

tell me. "But we are going to keep this book of Polaroids." I gave them the Polaroids and kept the icon and got on the plane to Iceland.

BAD ATTITUDES

There was one girl who gave me a really hard time. She wasn't that pretty and she was kind of short. Remember Marilyn Grabowski, the editor? She would always see something I never saw. She would see a girl and go, she looks like Cindy Crawford, right? I would go, no, not really. This girl was like five-three and a little overweight. "Well, make her look tall and thin," Marilyn said. "You can't make her look the same as Cindy Crawford," she would say.

So it was always a struggle. This girl was not that great. She had been a bartender at her college in Ohio. She would dance on the bar like "Coyote Ugly." The guys would tell her she was hot, but the standard for "really hot" is pretty low for a bunch of drunken college boys. Out here, you are just one of the crowd. She had this really bitchy attitude, like "I'm so good, I'm better than anyone else." I told her, "You know you are not, and you know we don't play that game. First of all, you're not even that beautiful. I am really struggling to make you look good, and you have been giving me a hard time for three weeks."

One day I just had it! So I said, "What do you want for lunch today?" She says, "I want a hamburger." So we get it for her and I slide it over to her, "Here's your hamburger." She goes, "I don't want that," and slides it back to me. I stood and said, "Listen Dorothy, you and Toto can go right out that front door. You think you are a 10 and you are about a 2 here in LA. You might be a 10 in Ohio but you are a 2 here. Pay the bill and get the hell out of here."

The next day she comes back in and says, "I'm so sorry. I didn't know I was being so mean." I had it. I don't know where Dorothy and Toto came from but I just saw this Midwestern girl and the first thing that popped into my head was "Now you're in LA, in the big leagues, don't be a bitch! If you give me a hard time I can make you look good or bad."

Every once in a while a girl would give me a hard time and I would say to them,"Why are you being so mean to me? I can make you look good or bad." A few said, "No, you can't; you don't have that kind of control." I would say, "Really? Watch this." I would change my lighting and I would change my lens. I would make her look short and fat and then change my lens to make her look tall and thin. Boy, that changed their attitude fast, then it was, "Oh, I'm so sorry, I didn't know." Well, they would see the pictures I did and then start thinking that's the way they really look.

Arny Freytag was a Playboy photographer for thirty-eight years. He has shot some of the most fabulous Centerfolds and models in the world. He is semi-retired and living in California. God Bless you, Arny, for all my sisters in making us look beautiful!

Ken Marcus –
Celebrity Playboy Photographer

All photos used with permission by Ken Marcus

I spent eleven years working with Playboy, photographing some of the most beautiful women on earth. I don't remember the exact number, but it was over forty or fifty Centerfolds and hundreds of calendar shots and editorials. Covers? You name it, I did just about everything that be done under the confines of Playboy. I had a lot of good times, I got to travel the world, see things I would have never chosen to see on my own, and met people that truly broadened my perspective of life in America.

I got involved with gunfights, death threats, attacked by a guy with a knife. – all kinds of life-threatening hairy events – just by virtue of the fact that I was the Playboy photographer visiting their hometown, obviously to steal away their virtuous young women and make them do dastardly things.

SOUTH PADRE/GIG GANGEL

We were in Brownsville, Texas, photographing Gig Gangel. Gig was from that part of the world and she spent time a lot of time surfing on nearby South Padre Island, a beautiful, idyllic place to shoot. What we didn't know was that she had gone to Hollywood and was going to become a Playmate. A former boyfriend of hers felt that it was a terrible thing she was doing.

We came home from a shoot one day. We were walking across a parking lot towards the hotel, and all of a sudden I hear this scuffling going on behind me. I turn around and my assistant at the time, a fellow named Joe Franks, saw this guy coming at me from between the cars with a big butcher knife. Joe managed to knock it out of his hand, wrestled the guy to the ground, and pinned him before I was even aware that there was something going on behind me. Joe just kind of yelled at me, "Get out of here, go on, I got this." We went back to the hotel and felt exhausted.

LUCKENBACH SOMETIMES ANNUAL WORLD FAIR

Rednecks from five hundred miles in every direction congregate at a sometimes-annual fair in Fredericksberg, Texas every year to drink beer and get rowdy, to watch motorcycle races and see how far they can throw flying live chickens. We, the whole crew, assistants, makeup artist and Gig Gangel, Centerfold were wandering around and Gig was wearing a cute little red outfit. Like, a little midriff, farmer-john sort of style, bright red, and her hair was all done. She looked like a celebrity, but she wasn't showing any nudity. These drunken redneck guys were showing great respect to her. They would look and follow maybe twenty feet behind her, and no one did anything that was out of line.

We walked past this little 80-year-old lady sitting on a bench. She looks like she's straight out of a movie from the past. She's wearing all black with long sleeves with little ruffles coming out of the edges of the cuffs and out of the edges of the collar, like a little old church lady. She's sitting forward, resting both hands on top of her cane and resting her chin on top of her hands. We walk right by her and, fast as a rattlesnake this old lady had that cane out and was jabbing this model in the ribs and calling her a "hussy." This was like from a hundred years ago and got right in our face. A Playboy Playmate got attacked by an 80-year-old lady with a cane.

DRUNKEN PLAYMATE EXPERIENCE

When you're dealing with women who are beautiful, but who come with all varieties of baggage and personalities, how do you deal with that? As a Playboy photographer, I get asked this question a lot. I have had to mention this before, as I was on the lecture circuit for twenty-five years and a lot of people want details about how to solve this problem.

My philosophy has always been: I'm not here to make friends; I'm not here to get a date; I'm not here to get laid. I'm

here to do a job and get the job done as rapidly as possible so that my clients like it, pay me, and assign me another job. That's the way I've always felt. So, I remember this one situation when we were shooting a Playmate and because she was going through a difficult period in her life, she had shown up drunk one day. We were shooting with an 8 x 10 view camera, which meant she couldn't wobble more than a half an inch in one direction or the other or the picture would be out of focus. We ended up opening the front of the bathrobe she was wearing. We took the belt of the bathrobe and wrapped it around behind her and attached it to two thirty-five-pound sandbags. She didn't go anywhere, and it helped her stand up straight. We got a great shot! We remember that Playmate!

DOROTHY STRATTEN
CHRISTMAS BLAZE

We were shooting a Christmas subscription ad in the studio, and we had spent a couple of days building this nice set that included a fabulous Christmas tree. This was in the middle of August, but we had her all lit up. We had a strobe inside the tree that was making it look special. We had spent the whole day working on the lighting and a Playmate was posing.

We finally got down to the very last pose, and we had taken her hair down and everything was ready for the final Polaroid. When we shot the final Polaroid, everyone except Dorothy whooped. She was still stuck on the set but the rest of us all ran into the dressing room where it was brightly lit so we could really study the Polaroid to make sure everything was ready to shoot. We're in there and we're studying, I am looking at everything; the editor was there, my assistant and the makeup artist. There was nobody in the studio except Dorothy. Then we hear this little voice go, "Ah, excuse me, but I think the tree is on fire." My heart stopped. Those are words you don't want to hear – fire in the studio.

I went running out there and sure enough, the strobe had caught fire, the modeling light in the strobe head had set fire to

some branches. Flames were about six or eight inches high. In the few seconds it took to run across the room to grab the fire extinguisher and run back, the flames were already twelve feet high and licking the ceiling. I put it out right away and spent the next three weeks trying to clean up the mess from the fire extinguisher. We never got the shot and have only that one Polaroid in existence.

LAST SIGHTING OF DOROTHY STRATTEN

I did shoot Dorothy several times for subscription ads, Christmas subscription ads and for the calendar. I was one of the last people to see her alive, actually. I was doing a Centerfold shoot, she stops by the back door of the studio, knocks on the door and she has her sister with her. She had just come from the airport, where she'd picked up her sister for her first time in LA. Dorothy brought her in, and they were here maybe forty-five minutes and they went back to the Mansion. Dorothy dropped her sister off and left for a meeting with her husband to tell him she wanted to split up. That's the last anyone ever saw her.

Her death was tragic and the police wouldn't tell her sister what had happened. They just came in the middle of the night and woke her up and told her to grab all her things and that they had to get her to the airport right away. Dorothy's sister was flown back to Canada, where her parents met her at the airport. They were the ones to tell her about Dorothy's death.

Ken Marcus shot for Playboy for eleven years. I can proudly say he shot my Centerfold and he resides in LA.

Photo by: Mikki Moore

Ric Moore –
Celebrity Playboy Photographer

Photo by: Rafn Rafnsson

Photo by: Brian "Stickboy" Powell

All photos used with permission by Ric Moore

HOW I BECAME A PLAYBOY PHOTOGRAPHER

People have asked me many times how I became a Playboy photographer. There is no one answer. A break like that is like building a bridge: many steps lead up to it being complete. And even after it's built, it can be completely broken or temporarily damaged for any number of reasons or events.

First, sometime after my grandfather's 35mm SLR was given to me, I dreamed of it. Then, like many eighteen-year-olds, I told a couple of my closest friends that I was going to become a Playboy photographer. I ended up at the University of Oklahoma as a junior. After much debate between my father and me, I finally had a direction. My dad was planning my future, and I was to either go into the family business of building and real estate, or the corporate world armed with a masters, or to continue on for a PhD and teach. The academic option didn't seem likely: I had been a disaster as a high school student. In college, as long as I was studying something I liked, my grades were surprisingly good.

As often happens with a kid getting out on his, or her, own, I had another plan. My not-so-secret plan, which my Father disliked and tried to exert pressure to stop, was to become a photographer. He thought it was okay as a hobby but not as a job. He personally liked photography, but only as a hobby. My secret plan was even better – to become a Playboy photographer.

I ran across two pretty awesome girls in Oklahoma who wanted to pose for Playboy. At that point in my career, I had ambition but lacked technical skills. I had purchased a two-head strobe kit with umbrellas. They were translucent umbrellas and I wasn't quite sure which way to point them. Luck was with me and I actually got some pretty great shots with each girl. Now came the moment of truth! I had to send the photos in to Playboy headquarters. As an avid reader of Playboy, I had located the address in Chicago. One problem was, I have horrible handwriting and I couldn't type. I went home to Brownsville as often as possible. My best friend Billy's little sister, Resa, was outgoing and knew how to type, and she had access to a

typewriter. In her benevolent and helpful manner, she agreed to type the cover letter for me. Her father, who was a saint of a guy, had brought home an IBM typewriter with the ball head: high-tech back then. Resa also had the slides I had shot so that she could type the number of each slide on the page.

After the letter was typed by Resa, her dad took a moment to read the cover letter, not knowing what it was about or to whom it was addressed. *Dear Playboy, I would like you to consider the following....* "Resa, is there something you want to tell me?" I can imagine him saying!

When she explained that it was for me, all was well. This story reminds me that in a big dream there are often small steps which can seem insurmountable. I often enlisted the aid of friends to help overcome such hurdles.

I didn't get the response I had hoped for from Playboy. But I didn't give up, either.

While the models I had sent were beautiful, they were not what Playboy was looking for in a Playmate at that time. Playboy can only pick twelve a year. They said, "Keep looking, you have a good eye!" That was enough to keep me motivated. These were words of encouragement, no doubt about that! Playboy told me, *You have a good eye!*

It would take me graduating from college, moving to Dallas and assisting for five years, before I realized my dream. I spent three years assisting a Playboy photographer.

I received my first assignment to shoot reportage for *Girls of Spring Break*, which went on newsstands in 1991. I got very lucky and had the opening shot.

When I started assisting after college, I really could have been a photographer on my own, not for Playboy particularly, but what my eye naturally saw in terms of composition and color and design was good. I had a few photographers comment on my work, saying nice things. One asked me why I was assisting at all. Another saw my photos and said, those are really nice photos of things that exist, they are naturally lit, which was a big deal. He then said, if you want to impress me, go into a room with nothing, and no light, and make a cool photograph. That advice was a bit harsh at the time. But it ultimately helped me become a top commercial assistant in Dallas at that time.

I assisted many photographers, each with different skill sets, and I learned from them. The shooter in Dallas was a good commercial photographer; he had good clients who hired him because his work was solid. This advice doesn't apply to everyone, though: if you're a photographer who shoots landscapes, shoot on! If, however, you want to be a commercial or editorial photographer and control your own lighting destiny, you have to understand and control light, hopefully continuous, and strobe. So I set out to do that.

I did have lucky breaks, like assisting a Playboy photographer, to help me refine my use of lighting specifically for the Playboy style.

NATIONAL SEARCH

I had the pleasure of being the Playboy photographer for the national search in the U.S. for Latin ladies in 2000. It was also the first time Playboy had gone to San Antonio for a national search. They were enthusiastic! Lots of interested potential Playboy models attending the casting, although San Antonio is a bit of a conservative town, or at least it was then, judging by the protestors at the event.

The ironic thing is that in those days, Playboy loved any kind of press. It created buzz, and that spread the word that Playboy was in town. This was the opposite of what the protesters wanted; it meant more girls coming out for a Playboy casting. In this case, extra buzz wasn't really needed. Since it was a new and novel event for the city, there was a lot of press, TV, radio and newspapers.

Playmate Maria Checa was with me for press interviews. She had saved me during an all-Spanish interview in Miami. I am okay for a while in Spanish, but I was getting grilled on a show something like *Nightline,* in Spanish on Univision, and Maria and her mom came to my rescue.

I had been one of the guys, one of the Playboy photographers doing a big search, but I had never been THE guy. Because of my background – living in South America when I was little, and growing on the border in Brownsville, Texas – I had an edge.

The previous search I had worked on was mega: it was the search for Playmate 2000 on the "Big Bunny" in 1998. This search had started off in Miami where the Bernola twins were chosen for Playmate 2000. They came out for the beginning of the Latin ladies search in their hometown, and did some press with me. They were not only gorgeous but awesome to work with.

Back to San Antonio: after the press was done on the first day, it was time to do what I had been sent there to do, that is, get to work seeing the women of San Antonio. I had been to many castings before, but never anything like this: I was the only photographer. I saw one hundred and eight girls on the first day. Maybe that doesn't sound like many, but, it was my job to find a diamond in the rough, to make sure that each girl had a chance to shine. Many had never been photographed by a professional photographer before, much less a Playboy photographer. Asking them to shoot in the least amount of clothing possible wasn't always easy. But a Playboy photographer had the confidence of asking this many times before. And prospective models usually knew this.

I felt like they could tell that I had a certain vibe of confidence, a genteel quality, and integrity. I was there to help a woman look her best, and the goal was to appear in the magazine.

We shot Polaroids during the casting. Trying to verbally pose a girl took too much time. It's a learning curve for a girl to become a model, and it means following directions right off the bat. I had no time for that learning curve. Physically touching the girl wasn't an option. So, with each girl, I would run over to where she should be, stand in and explain a Playboy pose, and then run back to my camera. My willingness to look ridiculous and to go out on a limb to show them what I needed usually succeeded in gaining their help, and it put them at ease.

I repeated this one hundred eight times the first day, trying to get the best look I could from each girl. Something else about the Playboy culture at that time, which is contrary to what people might have thought: women and their feelings were very important to those of us doing the castings. I had learned that when I was an assistant, and had continued as a Playboy photographer. The editors I worked with ensured this would be the way things were done. It was a Playboy tradition.

If a woman attending the casting was overweight a bit, or older, or not the right look, we tried to treat her same, spend time, speak with her, make her feel good about herself. I felt that any woman that crossed that threshold into the casting deserved my respect. It's not always an easy thing to do. In San Antonio we were trying to find a model for that pictorial and we hoped to find a Centerfold – only 12 per year! – a girl with just the right look and grace on camera, something special!

I think it was on the second day, I was slammed. Still over a hundred women that day. I was in the zone: greeting, quick hello, showing the prospective model what to do, shooting, "Have a great day!" and on to the next one. I caught up and was able to walk outside into the area of the suite where the editor Jim Larson was working with a woman to have the ladies fill out their paperwork. Security was keeping an eye on things. I was able to walk out into the room and say hello. I saw a very attractive blonde, but was she a Latin lady?

I walked up introduced myself and asked... She said "No, I'm not Hispanic. I just came to support my friend." I said, "Look, I have way too much to do today, but I would like to see you and we are both here right now. Go change into a bathing suit or whatever you have or can borrow and do it fast." I walked over to editor Jim Larson and said "What do you think?" He said he had seen her as she clearly stood out and had a "look," but could I take on extra work when I was already swamped? I was sure that I could. But where was the girl? I went to the bathroom suspecting (and rightly so) that she was primping. I told her it was right now or I couldn't see her at all. I had been caught up, but now girls were about ready to walk in, ready for their shot. She came into the casting room and I ran her through the poses. She was easy to shoot. She looked great. I thought to myself, *Playmate!*

She left and I was back to the long line of women to see. Later that day, a stunning Hispanic brunette walked in. Again, I took time I didn't have and we talked for a few minutes while I shot her. She had the body of someone that is at the gym every day. She was a vixen, meaning large upper measurement, a gorgeous face and was very well-styled and put together. But when we spoke, wow! She was brilliant! I asked her if this was the right

move for her, as she was clearly a professional woman. Would being associated with Playboy harm her career? She assured me it's what she wanted.

Special thanks to those I worked with over the years: the editors, Jeff Cohen, Kevin Kuster and Gary Cole. But especially to my crew of many years, Mikki Moore, my producer! We took sides over the details of every shoot which made both of us better. My assistant, "Stick Boy" who, at six feet six inches tall, took the higher ground literally and figuratively. And of course my makeup artists, Elisa and Eden.

Ric lives in Dallas, Texas and still is an amazing photographer. He has a book coming out soon about his life experiences and photographic adventures.

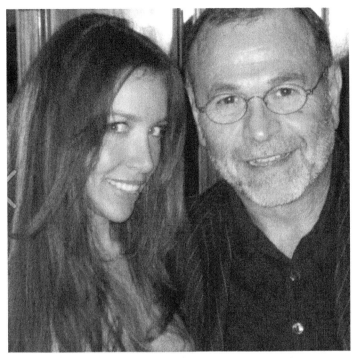

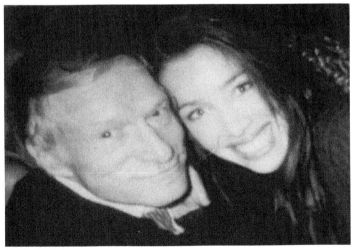

Mikyla Moore –
Celebrity Playboy Photographer

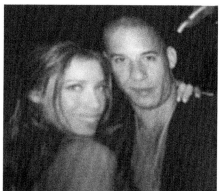

All photos used with permission by Mikyla Moore

Once upon a time I was a little girl from Liverpool, England with the big "American Dream." In short, my fellow Brits, "the Spice Girls" sum up my career with Playboy perfectly with their ever-so-famous slogan, *Girl Power.*

I knew from a very early age that if I wanted to get to the land of *Dallas* and J.R. Ewing, the grand US of A, I would have to make it happen myself. So I joined the circus; I really joined the circus. At 17 years old, I flew on my first plane trip and landed in Mexico and joined the cast of *Circo Tihany*, a spectacular international circus which, it was rumored, would one day tour the U.S. I had attended performing arts school in England where I had trained to be a professional dancer. Here I was dancing in this huge extravaganza with fifty other British girls and boys touring every town in Mexico. The circus finally came to the U.S., and I said goodbye to the motorbike-riding monkeys and disappearing elephants and I found my way to Texas: J.R.-Ewing land!

CUTE BRITISH ACCENT, TEXAS SIZE BOOBS!

So, with nothing but a cute British accent and an okay-looking face, I managed to find my J.R. Ewing in the form of criminal attorney Edward Chernoff, the same attorney who represented Dr. Conrad Murray in the infamous Michael Jackson death trial. I met Ed at the first gym I went to. I saw this gym which was a wall of windows, and everyone inside was all shiny and perfect, just how I wanted to be. I saw this hot guy in a pink muscle top – I never dreamed he would be clever *and* hot. But, I knew the second I saw him I wanted to marry him, so I started in a very loud British accent to get his attention. Funny thing was, he had already seen me and wanted to talk to me. That was the beginning of my J.R. I was married to him two months before the birth of our son, Fate. I decided to send a picture of Fate and myself in to Playboy suggesting they do a story on "hot moms," and they wrote back requesting nudes of me. That's when I had to tell my hubby what I was doing. He took some Polaroids and

I was picked to appear in Playboy's Special Editions. I never thought I was that pretty, far from it, but I looked good in photos and I had just purchased the essential accessory for every young girl in Texas—my big, fat made-in-Texas boobies.

Playboy liked me so much they gave me hosting jobs, and I did several pictorials for the magazine, *The Girls of Spring Break, Women of Radio*, and made the top-twenty readers' choice supermodel edition. I also made it into the Celebrities of 2001. As well as modeling jobs for ads, my cute British accent and cheeky wit actually made me appear far more attractive that I ever was, so life was great! That was when I was on billboards throughout Houston and became an on-air celebrity for 107.5, "The Buzz" radio station.

I appeared in many special editions and went on to host the Playmate 2000 bus with Kevin Kuster. I toured and did press appearances, meeting all the girls trying out and working with the Playboy photographers. That opportunity was given to me by Kevin Kuster, who took a chance on me. He worked for Jeff Cohen at the time. Both men became mentors and we are still good friends to this day.

Here I thought I was this ugly moppet-faced girl from nowhere-ville in England! And just by showing my made-in-Texas, USA boobies, I was getting to meet celebrities non-stop at Mansion parties, host TV shows and get this door of opportunity. What I did with that door of opportunity was totally up to me, and I fully intended on knocking it down.

PART OF THE PLAYBOY CREW

With no training or education in producing, styling, makeup or art directing, I figured out how to land a permanent position doing all the above for our Texas-based crew. Here's my secret; I just asked! As I remember, the worst they can say is no. I was eager, reliable and worked harder that anyone around me, constantly studying everything the crew members did. I was so lucky to have very important powers at Playboy – Kevin Kuster and Jeff Cohen – who thought I was funny, mostly cheeky, but most importantly talented with potential. They took me under

their wings and taught me just what I needed to know. I got yelled at sometimes when I got things wrong (which was a lot), but they gave me an unconditional opportunity of a lifetime to work behind the camera in every way. It is the single most precious gift anyone has ever given me.

RIC MOORE AND MY J.R. EWINGS

As the years went on, I went from in front of the camera to behind the camera, learning from the very legends of Playboy.

One Legend let me be his shadow, the cream in his coffee, and mostly pain in his ass. That legend is photographer Ric Moore, who opened up his wealth of knowledge of lighting and shooting directions like no other. I became his producer, and for seventeen years we worked side-by-side sharing the good with the bad, and always making sure to over-deliver on every job we had with Playboy and others we worked on together. My relationship with Ric Moore has lasted longer than any of my marriages. There have been four J.R.s.

MY BIG BREAK

I made it full circle when my boss at Playboy made me a photographer. I still didn't know all the proper names for all the lights, but I knew what he wanted, I knew what our readers wanted, and I was willing to work longer and harder than anyone else to get it right.

In 2010, one of the pictures I shot appeared on the cover of the Big Playboy issue. I shot the promotional cover. Me, that kid from Liverpool who just wanted to come to America to marry J.R. Ewing. Since 2008, hundreds of my images have appeared in countless Playboy publications and I have worked with some of the most famous Playmates and photographers in the Playboy enterprise. All because a cheeky British girl asked if she could!

Unlike many of the photographers, I have the unique ability to multi-task on my shoots, since I learned every aspect of the shoot from the ground up. I can do makeup, hair, style, art

direct, produce the picture. Not bad for a kid who did not go to school for any of it. I had been given the chance to learn.

ACCOLADES, LIFE AND THANK YOU

While writing this for my dear, beautiful, crazy friend Charlotte Kemp, I took a look back at my work and realized, I am good, and I did good. I have so many stories and so little time; pictures of a certain baseball player in bed, clearly showing he is by all means the "hit king" in the bedroom. Then I went on to shoot his current girlfriend for Playboy – now, that was awkward. I also spent time with a sweet, quiet "Junior" who drives his car really fast in circles and liked to sing *Dancing Queen* with me as I drove very slowly in my car.

Thank you, Jeff Cohen, you are an opportunity maker and changed my life forever.

I still live in Texas and remain a contributing photographer for Playboy; I now mainly shoot the everyday woman and give her a chance to shine. I am able to transform Mrs. Soccer Mom into Mrs. Centerfold and give every woman whoever fantasized about it her own "Bunny Experience."

To anyone living on my hometown street back in our village outside of Liverpool, "I DID IT. I REALLY DID IT."

Thanks, Playboy, for everything – the good, and the ugly – we have had a bloody good life, haven't we!

Miki Moore has photographed and been with Playboy for over twenty years. She herself is a beautiful "chicki" with three beautiful children and has an uncanny eye for detail and love for her work. She made it!

Ralph Haseltine –
Celebrity Photographer

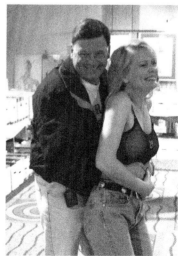

All photos used with permission by Ralph Haseltine

HOW I BECAME A PHOTOGRAPHER

The question I get asked about the most is how long have I been in photography. The true answer to that is almost thirty years. I began my film career with a leading Fortune 500 company when I was transferred to the corporate Industrial Engineering Department in 1989. It seemed that in one of our meetings I was overheard talking about a new consumer-grade video camera that I had purchased. That seemed to be enough to "qualify" me for this assignment, which was writing, storyboarding, filming and editing all of the work methods of United Parcel Service.

Well, they were half right! I had been around the company long enough to have performed all of the different jobs as a union employee, and then teaching them as a supervisor and manager. What I lacked were skills behind a camera. My boss, whom we not-so-fondly called "Dickhead," back-stabbed the person who should have had his job, a person who did have a vast knowledge of video. At any rate, I had the good luck of having Daniel Wiggins on the team with me. Daniel was a supervisor like me, but from another district. He was currently going to college at nights to complete his degree in Television Production.

Danny had the skills, camera knowledge and lighting experience to get us through, along with the editing house we were using, Video Impressions out of Aurora, Illinois. Its co-owner, Mike Hislop, and Danny became fast friends with me and virtually took me by the hand and spent two years teaching me everything there was to know about video, lighting and editing.

Fast-forward a few years, and the digital camera revolution was born. I mean this regarding professional-grade cameras, as there already were cheap and terrible consumer-grade digital cameras, but Kodak broke the mold with their 700 and 500 series digital SLRs. I managed to scrape up the capital I needed for my first, a brand new Kodak 720, which was essentially a Nikon F5 camera body modified to fit the Kodak bottom. Like all new technology, and like video, everything was expensive and heavy. The Kodak 720 batteries (it could hold two) weighed a pound each. Now, add the camera and base for shooting and you found you were getting gorilla arms. At any rate, I progressed

from there and had always been an avid Playboy reader as well as a fan of Ansel Adams and other giants in the photography world. It was the lighting that always caught my eye. I would look at the photos and sometimes wonder why the photographer lit the subject that way. Difference of opinion is always good, and I had also learned that a photographer will light something a certain way on purpose for their own artistic expression. I know I do that, and my lighting is what sets me apart from the crowd—or so I am told.

So, I began to work with a few models on a Time for Prints basis (TFP) and found that I was actually very good. All of that lighting training was being put to the test. I had my first "real shoot" with a Playboy special edition model, Ferrara Daum. The shoot went exceedingly well, and to this day, Ferrara still says that no one has ever shot her as well as I did.

I had been sharing studio space with two other photographers, but found this to be a bit of a hassle. We all were shooting or wanting to shoot at the same time, so eventually I hung out my own shingle. The money was beginning to come in from the shoots and things were going pretty well, so I opened up a real estate photography and virtual tour business as well. That grew to cover most of the Southwest, Midwest, Southeast and Eastern states, other than New York. As the cash rolled in from that, I improved my studio with more lighting and props and began to hold workshops there.

A few of the models who I have been lucky enough to have in my studio have been Playboy Centerfolds. Having shot with Playboy Centerfolds and models, naturally my goals were to work with as many Centerfolds as possible. I have become friends with a good many of the girls of Playboy and still help them out with graphics, posters, and editing, and I am proud to call so many of these wonderful women my friends. I am a published photographer in several books, art galleries, coffee-table books, twenty *Page 3* girls for Murdoch Publishing, magazine covers, and have been the featured photographer in many of these magazines.

HOW I STARTED SHOOTING CENTERFOLDS

I had very good success in shooting with all types of models, joined several sites and was getting rave reviews on my work. I guess we all have that uncertainty of how good we really are until we hear otherwise from photographers we respect. I had a fresh new model walk into the studio for a portfolio shoot. She was the most amazing young woman, just 18 and beautiful to the max. Not to mention, she was five-ten without shoes, bright blue eyes, natural blonde hair, and full hourglass measurements. The minute I saw her, I knew she was Playboy Centerfold quality.

Still what I considered a newbie to all this, I sent off a few of her photos to some of the photographers whose work I respected to the max, and to one in particular who has sent more women to Playboy to become Centerfolds than anyone else that I could think of, Andy Pearlman. My subject was shy, and I did not have much experience at the time with lingerie or fashion photography. I had never done nude shots, and neither had the model. I asked my mentors what they thought of this woman's potential for Playboy and if they wanted to do the shoot. Everyone responded the same way: "Why won't you shoot her? You are more than qualified to do so." One of the photographers, Marc Grant, whose work always stuns me, told me that he kept raising his standards to keep up with mine.

Well, as it turned out, the model's parents really put the hammer down on her for wanting to try for Playboy, so that shoot never came to fruition. Shortly after that, I went to my first Glamourcon and met Debra Jo Fondren. She was so down-to-earth, so much fun to talk with, and it was pretty quiet that morning. So I spent quite a bit of time with her as she actually asked me to join her behind her table and just keep her company. Of course, I jumped on that opportunity.

We all put the Centerfolds up on a pedestal, but I was finding out as the day went on just how down-to-earth the girls were, and I became comfortable talking to them all. I asked Debra Jo if she would shoot with me, and her rates were below what I expected and so, of course, I jumped at the chance to shoot with

this incredibly beautiful lady. I ended up coming back again the next day, feeling that I was now firmly pulled into the sisterhood of the Playboy Centerfolds. Over the years, many have become good and fast friends of mine, not just on social media but personally. We talk on the phone, text each other, have been to dinner together, and I consider them all very down-to-earth but still so very classy ladies.

MALLOY AND STEPHANIE, PLAYBOY MODELS, PRIVATE ISLAND SHOOT

I should have seen some of this coming, but things sometimes tend to move fast in our business. I was sitting in my office and my phone was ringing off the hook with Malloy Kuntzler (PB), Holley Dorrough (PB Centerfold April 2006) and my MUA, Sally Kempton, all calling me from the U.S. Virgin Islands where they had been for a day and realized that I was not there. After several calls, I somehow managed to get a flight out of O'Hare Airport the next morning to meet them.

After landing in St. Thomas and finding a water taxi to Water Island, I was met at the dock with honors and a bevy of beautiful models yelling my name. Warm welcome indeed! After moving my equipment and with what little I packed on my bed, I was approached by two of the models as well as photographer Robert Monet out of Denver. They prodded me to join a small group who had chartered a boat to take us to an abandoned island. So, three models and three photographers went to shoot on a beautiful natural sandy beach with palm trees bending out over the water.

That first night I stayed up late as we did some shooting by the pool. I had also been asked to do a private shoot for one of the models who had contacted me beforehand. She was disappointed when I had originally told her that I was not coming down there. Well, just by showing up, I guess that shoot was predetermined to happen.

I was rudely awakened at about five the next morning to take boat to the island. Rain poured, but the captain of the boat

assured us that it was just passing storms and that we should have plenty of sun on the island. Did I mention that the boat had a cabin for only the captain and his mate? The rest of us were relegated to the open seating in the bow of the boat. Did I mention that there was a monsoon? So, you get my ass up at five, put me in the bow of a boat in driving rain, no coffee, no breakfast, and smoking at your own risk as it's raining so hard that you might get one or two puffs off of a smoke before the marble-sized rain drops douse it for good.

Now, it seems that I managed to pick what I though was a good seat but, due to the shape of the boat, not! Every time we hit a large wave, the water would fly over the bow and hit me square in the face. I could have moved, but there was nowhere to go! We did get some breaks from the rain on the ride to the island, but I was soaked.

We arrive at the island and find out that the draft for the boat will not allow it to beach or get even close to shore. So, over the side I go and we begin to act like bearers carrying equipment on our heads to keep it out of the water. If I wasn't totally soaked already, this definitely capped it off. The captain and the mate anchored the boat and ended up being our grips or reflector handlers as we shot the models at sunrise, but due to the storms there was too much fog in the air.

We did capture some fantastic beach shots, some glamour and nudes that, at least for me, was tempering my grumpy mood for having been awakened before five and given a one-hour soaking boat ride, bumpy as all hell I might add, so yes, those bow waves did a job on me. The images, though, had me pumped up, and the models as well. We showed them what we were getting in the camera and they were all excited.

Around eleven we are all pretty tired and decide to make our way back to Water Island, so reverse the process of being bearers with equipment on our heads, passing equipment up to one of the people on the boat. At this point, as I am handling equipment, my Oakleys (two weeks old and two hundred and sixty dollars) slip off my shirt where I had them tucked in by the arm and they hit the water, only to be swallowed up by the sand and waves. Gone in less than a second or two. Now I am beginning to feel grumpy again, and as I pass my equipment bag

up to the boat, the guy loses his grip on my bag and – yep, you got it – right into the ocean! Three cameras, a ton of batteries and five extra lenses. Heart-stopping for any photographer. Luckily, the bag was pretty waterproof and I managed to grab it just as it hit the water, but it did take a dunk. Luckily, nothing was hurt or damaged so no harm done.

So, we begin the voyage back and, feeling at least that the sun has been out since like six, hoping for an uneventful trip back to the Island. The captain of the boat had filled a cooler with some beer and wine coolers which he had been instructed not to make available until the trip back. The models jumped on that one. Now, they are young, but old enough to know their limits. And none had anything to eat, as we had left the so early for our trip.

The sun was hot on the ride back and the models had been nude on the beach anyway, so one had put on her thong bottom and the other two stayed naked and began to consume the now-available ice cold beer. Well, we had to pass through an inlet where the Caribbean and the Atlantic meet, where the water is extremely choppy. It was just before this that one of the models, Malloy, who had been drinking more than I had realized, decided that I deserved a lap dance for coming down to shoot at the last minute. The engine from the boat was so loud you could hardly hear, but I got the essence of what she was saying and she stumbled over to me and began to give me one fantastic lap dance.

Now I have this totally nude and very attractive lady on my lap, grinding her ass into me and taking my hands to hold her breasts as she does her thing on me. What she doesn't realize is that I am hanging on to her breasts a bit tightly because we had hit the rough water and the deck was soaked, so I have this really bad feeling that if I don't hold her tight on my lap, she may fly across the deck and get seriously hurt. As all of this is happening, one of the models had been sitting on the bench in the front of the boat on her knees, topless but with her thong on, and we hit the rough water. To make matters a bit worse, the rain came back in spades for a while, and everyone was getting soaked, but I am still getting the lap dance of a lifetime. I realized that Malloy had more than one or two beers and she was really feeling good

and at that point, so was I! The model in the front of the boat tried to cover herself with a blanket, and as she did, the boat heaved heavily and she fell forward with the blanket covering her head and the rest of it draping to the deck of the boat. Now, you have to visualize this as I'm getting pretty much humped, and I am not going to plead complete innocence here because I am getting turned on. I'm holding both Malloy's breasts in my hands and, yeah, the nipples did get tweaked a few times. Stephanie, the model who fell forward and is half covered with the blanket, is bouncing hard up and down where we can only see her ass out of the blanket and she keeps bracing herself with her arms as she hits the floor and is using them to stay at least partly on the bench, but all we can see is this beautiful ass bouncing up and down and the outline of her head under the blanket as the sea throws us up and down, and with each pounding wave she's trying with all she has not to fall off of the bench.

All of this is happening in a span of only maybe four or so minutes and, well, it looked like Stephanie was giving head to something very large as her head goes up and down under the blanket. Malloy is rubbing hard on me and I look at Robert Monet, one of the photographers who came on this little junket, and he is laughing his ass off, as at least he can see all of what is going on. Luckily, the rough patch passed and Stephanie was able to secure herself back on the bench and Malloy was really feeling that beer now after all of that bouncing, so I help her back to the bench so she can sit safely, and Robert is still laughing his ass off.

Luckily, by this time, we had smooth sailing and made it back to Water Island in one piece!

JACKIE MORRISON

Sometimes, we as photographers find ourselves in unexpected situations. This is one of mine. I usually have a strict policy about not touching models during shooting, and though I have dated a few models, I try to make it a personal policy not to sleep with them, in general.

I was having a workshop at my studio and one of the models

that I brought in was Jackie Morrison, who was in featured in a Playboy pictorial called *The World Class Charms of Small Town Girls* in September, 1996. Now, I do have to admit that I always liked her being from Illinois, and we had chatted some and talked about doing a shoot together, and this seemed to be the perfect time and place for that. Up until now, Jackie had not done any nudes, but implied that lingerie was okay for her.

She arrived late Friday for the two-day workshop, Saturday and Sunday. A few of the other models were already there in the hotel as well as a few photographers hoping to book an early shoot with some of the models on Friday night. A few of us went out to dinner and had a few drinks and before long, it was coming up on midnight and it was suggested that we all turn in and rest up, because the workshop can be tiring!

I drove Jackie to her hotel and asked her if she wanted me to walk her in as she still had her suitcase in my car. Being a gentleman, I was going to help her up to the room, an offer which she gladly accepted. I need to preface this a bit: about a month before the workshop, she went through a breakup with the guy she had been seeing and she just seemed to be very quiet. I figured that she was tired and still down from the breakup. We went to her room and I dropped off the suitcase and turned to say good night when Jackie wrapped her arms around my neck and pulled me in close for a long, wet, lingering kiss, which lasted for about five minutes, about enough time for both of us to undress each other. I picked her up and carried her to the bed and we spent the next several hours making mad, passionate love.

We both dozed off but I woke around four in the morning, and realized how much work I had to do for the workshop to start on time on Saturday, so I gave her a gentle kiss while she slept, and I left to try to get an hour or two of sleep. I had to be up at six to prepare for the rush of photographers. (I think we overbooked it: we had twenty-one show up!) As the day went on, Jackie and I sort of flirted casually by touching hands as we passed in the hallways and gave each other that look. I guess it was not all that subtle because I was being asked if we were an item, to which I had to answer no. We did have a night of lust, but I did not want to diminish her reputation in any way.

The workshop went very well on day one and we would all usually go to a local restaurant for dinner together, and there were some private shoots happening later that night as well as some people going to their own hotels for a nightcap. I was shuttling Jackie back to her hotel and I pulled up and stopped, but she suggested that I park the car, so I did. I opened her door for her and she reached for my hand and pulled me towards the hotel. We held hands up to her room and once inside, when she closed the door, it was like a lightning strike. The two of us began kissing and tearing each other's clothes off. I picked her up and laid her once again on the bed and we spent the next five or so hours nonstop making love in every position imaginable, not to mention taking care of one another, if you get my drift.

Fast forward to four in the morning and I am leaving with no sleep, and I have to set up for workshop day two, Sunday.

I had kissed Jackie good night and told her that I would give her a wakeup call at seven so she would enough time to get ready before I picked her up. She opened the door, showered, clean and totally nude. She took my hand, walked me to the bed, undressed me and we picked up where we had left off the night before. Luckily, I was not needed at the workshop until around noon so we spent the morning in wild, passionate sex until I told her we needed to get to the studio, and we both really needed a shower.

It was apparent to everyone that we had been spending time together. She began doing some topless modeling, and when she was not modeling, she waited for me in my private office in the studio where we had a lot of those long, wet lingering kisses behind closed doors.

Ralph E. Haseltine began his film career with a Fortune 500 company. He quickly mastered his craft and as well as emerging digital photography technology. He started shooting models and was hired by Playboy to shoot for a special edition. He graduated to shooting Centerfolds and continues to work with them on graphics posters and other projects. Ralph's work has been published in several books as well as art galleries and coffee table books, and he has been a featured photographer in many magazines, including shooting twenty Page 3 girls for Murdoch Publishing.

ACKNOWLEDGMENTS

To every Centerfold who helped bring their own
true stories to life.

To every photographer for painstakingly making Centerfold's
and models look like goddesses while sharing their experiences
with me for this book.

I would like to thank Cyndy Gyer celebrity model.
I would like to thank the Centerfolds who are no longer with us
for sharing their stories some 18 years ago.
We will miss you forever!

Cynthia Myers
Carole Vitale
Judy Tyler
Nancy Harwood
Pamela Bryant

I also want to ackowledge and thank Sandy Mccall, Rae
Attarian, Joe Coccaro, Danielle Koehler, John Koehler for their
patience and help to get this book on the road.

To my agent Leticia Gomez for her belief in this book.

A.O.W. My heart....

Thank you all from the bottom of my heart.

Charlotte Kemp

CPSIA information can be obtained at www.ICGtesting.com
Printed in the USA
BVOW11s1222141015

422403BV00015B/99/P